LITURGY AND THE ARTS

LITURGY AND THE ARTS

Albert Rouet

Translated from the French by
Paul Philibert, O.P.

A Liturgical Press Book

The Liturgical Press Collegeville, Minnesota

Designed by Frank Kacmarcik, Obl.S.B.

This book was originally published by Desclee de Brouwer under the title *Art et Liturgie* © Desclee de Brouwer, 1992. All rights reserved.

Library of Congress Cataloging-in-Publication Data

Rouet, Albert, 1936–
 [Art et liturgie. English]
 Liturgy and the arts / Albert Rouet ; translated from French by Paul Philibert.
 p. cm.
 Includes bibliographical references.
ISBN 0-8146-2393-X
 1. Liturgy and the arts. I. Title.
NX660.R6813 1997
 246—dc21 96-41896
 CIP

Contents

Translator's Introduction

It is refreshing to come across writing about the role of the arts within Catholic worship from a perspective that refocuses the question. Often what seems to be the question is "what style of architecture or what school of painting or sculpture is appropriate or mandatory?" More pointedly the same question can become "are we stripping away art objects or are we hanging on to everything from the past?" This book centers on another question, namely, "what is the purpose of worship and why are the arts an irreplaceable part of good liturgy?"

The document of the Bishops' Committee on the Liturgy *Environment and Art in Catholic Worship* (1977) was another example of getting the questions right.[1] It made a powerful statement about the extremely potent effect of ritual objects, architecture, vestments, and sacred space on believers. It made it clear that every culture has a contribution to make in witnessing to the mystery of God's Spirit within human experience through the means of the worshipping life of Christians. It remains a powerful and prophetic state-

ment from inside our own North American society of the role of the arts in worship.

This book is powerful in similar ways. It is remarkable to discover the author's passionate feeling about the need for dialogue and cooperation between artists and Christian communities. It is good as well to have this reflection take place within a context of such deep honesty. Bishop Rouet pulls no punches. He is forthright about the poor relations between those responsible for diocesan and parish administration and those in the forefront of artistic production.

His work, however, is fundamentally theological. He expresses patiently a number of principles that are of great importance for pastoral life. By engaging these ideas with such enthusiasm, he illustrates their potential significance. The following ideas are among the key, seminal principles in his argument.

First, he speaks from the stance of the Pauline vision of the ingathering of all things into the "new creation" of God's kingdom. Throughout, he writes with a vivid sense that God is still very much at work on the "new creation." Believers should be fruitful collaborators in the project of bringing about a new earthly reality.

From the author's point of view, the arts are indispensable for wholesome human living and necessary for the incarnation of faith. He is convinced that human action is parabolic—that is, like a parable that explains the meaning of life by creating a new understanding. Parables reverse expectations. They make us look at reality in a new way. Parabolic activity—both

artistic and liturgical—turns the world on edge to make us see how it is penetrated with grace.

So another principle of Rouet's theology is that the arts are not for ornamentation, but for evocation. Their role is not to fabricate an alternative world alongside ordinary life, with all its burdens and ugliness, even though the beautiful can be a relief from the heaviness of daily tedium. Rather, the arts have as their role the disclosure of holiness within the ordinary. In a world such as that described by Paul in Romans 8, a transformed incarnational world, the role of the arts is to make plausible the extraordinary density of reality for those who live "in Christ." As Teilhard de Chardin says, "God is inexhaustibly attainable in the totality of our action."[2] The function of the arts in the Christian life and in liturgy is to map out the location of God's presence and to detonate the sacramental potential of the world.

This is why for Rouet the Church is not a building, but a community. Christian life is not a career, but a sacramental witness of persons "who live . . . not themselves, but Christ lives in them" (cf. Gal 2:20).

For Rouet, there is a strong parallel between the hidden ground of faith and the elusive vision of beauty. In both cases, there are strong moments and weak moments. Strong moments of faith are moments filled with religious experience when nothing has to be explained to us, rather we are overawed by the abundance of some beauty, goodness, or grace in our lives. Weak moments of faith are moments when trouble,

fatigue, scandal, or counter-witness cause us to won-
der if we dare continue to believe. In such moments,
we hold on as if by the tips of our fingers to the mys-
tery of God. Likewise, strong moments of beauty are
moments where purpose or inspiration are so power-
ful that artistic expression flows like a river, even a
waterfall. We are carried away ecstatically by the
sense that all our energies must be given urgently to
the embodiment of our expression. On the other
hand, weak moments of beauty are moments of
struggle, hard-scrabble, self-doubt—moments where
we have to force ourselves to continue progress on a
projected plan of action.

Another parallel between faith and beauty is that
both thrive in a corporate context. Artists genuinely
suffer by being isolated from community. It is true
that since the nineteenth century we have created a
myth of the romantic artist who finds authenticity in
lonely struggle. However, the work of the artist is
meant to be the work of "one member . . . in the
Body" to use the metaphor of Paul in 1 Corinthians 12.
In both cases, the believer and the artist experience a
kind of moral surrender as well. The believer surren-
ders to a trusting relationship with the witness who
speaks to his or her heart. The artist surrenders to the
painful recognition that no artifact or craft will ever
do justice to the aesthetic vision in the poetic dream.
Yet, in both cases, the work must be done. And the
work is not just to believe or to make, but to bear
witness to a life of the Spirit that is in touch with
God's own reality.

Rouet's vision is particularly helpful when he begins to apply it to such dimensions as music, sacred space, dance, and the other arts. Readers have in store for them a genuine joy in seeing a thoughtful Catholic bishop sort through important questions that develop a convincing argument that the Church cannot do without the arts.

As in any case of translation of a literary work, so here certain decisions have had to be made. One decision was to use as far as possible colloquial English in expressing what is sometimes culturally or aesthetically foreign to us. Another has been to try to render the text as informal as possible. (Rouet's chapters were originally oral discourse—papers given at various congresses in France). There is still a taste of Gallic language floating through the manuscript. I hope that I have facilitated rather than impeded access for English-speaking readers to this wonderful book. To Bishop Rouet, in the name of all readers of this edition, I offer sincere thanks for a valuable contribution to thoughtful dialogue on a difficult topic.

Paul Philibert, O.P.
University of Notre Dame

NOTES

1 *Environment and Art in Catholic Worship* (Chicago: Liturgy Training Publications, 1986).

2 P. Teilhard de Chardin, *The Divine Milieu* (New York: Harper & Row, 1965) 63.

Preface

Despite the kind request of friends and the acquiescence of the author, this publication of a series of articles on liturgy and the arts remains a not completely satisfactory contribution. Too many topics deserve to be treated that don't fit into the particular points of view addressed in these pieces. Despite this valid objection, however, why have I agreed to publish these independent chapters?

Above all, I feel that these chapters are not independent one of the other in every respect. The relationship between the arts and liturgy is not first of all of an intellectual nature, but rather existential. Each day, the liturgy is celebrated anew. Likewise, each day an artist finds himself or herself in front of a work to produce, no matter what came forth the day before. Liturgy and the arts are daily labor, necessities in their own realm, "our daily bread." The continuity of the job to be done cuts across the discontinuity of the particular tasks. I hope that some similar kind of unifying thread will carry the reader through the diversity of these chapters.

This wish is not ungrounded. Despite the diverse occasions which were motives for these articles, each one returns to the same point of departure and shares the same concern. The liturgy cannot be content only to celebrate what is exactly required for the conditions of validity. Without yielding to sensationalism, we need to transform participants into an assembly and to create a shared and common prayer. An obsession with rubrics becomes quickly evident; it turns the celebration into an action insensitive to its environment and makes it a theater of abstractions. Liturgy requires beauty in order to achieve meaning. Ritual meaning is not wrapped up in itself, but becomes an invocation, a reaching out toward the One who invites us. Each element of ritual participates in this spirit. To celebrate well is to allow oneself to be drawn out of oneself.

For their part, the arts are tempted to become self-satisfied. They can be infatuated with their own images. True beauty flees almost immediately, once it is glimpsed. It is never possessed, only desired.

Art and liturgy are invited to join forces in a realm beyond themselves. Their rapprochement is transcendence. This is the fundamental conviction of these chapters. In the end, something very simple needs to be understood: liturgy and the arts are both the work of servants, work that demands much care and attention.

If, despite their limitations, these pages help to clarify how liturgy and the arts are united in the One

who is supreme beauty because he is the icon of the Father they will have fulfilled their goal. They have been written expressly to invite this collaboration.

Preface to the English Edition

Writing a book is always related to concerns that belong to the author's own situation. The liturgical reform, begun well before the Second Vatican Council, has had a rather surprising result in France. On the one hand, it is manifestly more and more cerebral and yet, on the other, it has become a mirror held closer and closer to immediate reality. Between intelligence and feeling there has come to be a great divorce. This is a fact which can be felt in the whole of French society, so it is inevitable that it would touch the life of the Church.

One result has been that liturgy has become a symbolic place for the struggle for or against modernity. To wear a chasuble is to be traditional; not to wear it is to be modern. When we arrive at such extremes, which are not of the symbolic order but simply a kind of sign, it is evident that we have ceased to reflect upon what is really at issue.

Well, what is at issue in the liturgy's rapport with the arts? Notice that at present artists have withdrawn from our churches and are running fast. The Church no longer has abundant means to play the role of patron; in addition, the furnishing of churches is inspired more by a desire for poverty than a search for opulence.

This has led to misunderstandings between the Church and artists. This book, *Liturgy and the Arts*, was written in this context. My idea was not simply to design a bridge between faith and the arts, but to wonder if this conceptual bridge is meaningful enough to bring about its construction. What follows, then, is a patient examination that begins with a delicate situation which is on the way to becoming better. I begin by asking what rapport might exist between the arts and faith. Both sides touch upon the symbolic dimension of humanity and the manner in which it expresses the meaning of our life. The arts are indispensable to human existence; they are needed to achieve the incarnation of faith.

When we speak of the arts, we do not refer to a particular school, much less to an academy. When we speak of faith, we mean to indicate something that is a productive element within culture. We too readily forget this. Faith is not simply an individual thought process, nor personal opinion; nor is it only the *public* witness of a person. Faith produces a way of living, therefore culture, and thus, art.

Yet from the point of view of symbolic production—including the fundamental act in which the Creator, on the one hand, and Christ the Savior, on the other, come together within humanity—art and faith may be able to find again a common path.

✝ Albert Rouet
Bishop of Poitiers

CHAPTER ONE

The Arts and Liturgy

"You enlarge my understanding"
Ps 119:32

The liturgy is an art which uses other arts. Does it use or does it combine arts? This key question is based upon choosing between a *practice* which *uses* and a *harmony* which *combines.* "Usage" applies and reduces artistic energies to set purposes, and the artist suffers. "Harmony" organizes elements in such fashion that each, in its proper order, conspires to create a new work. Everyone dreams of harmony like this.

Put this way, the dilemma solves itself. To "use" is not of itself something pejorative: the celebrant uses a missal whose binding might be a work of art; the organist uses musical compositions some of which are magnificent. The purposes of the liturgy arise out of a tradition rooted in the apostolic witness. The purpose of the liturgy is already given to it, it precedes the liturgical act. "Harmony" might seem at first view to

1

be preferable, but this harmony does not invent the liturgy, rather it receives the liturgy as an event to be celebrated. Still each celebration calls for preparation, and even requires some new composition, or else it will fall into categories of mere habit, boredom, and finally insignificance. The way we celebrate has everything to do with the meaning of the liturgy.

Far from being a clear opposition that allows a facile antithesis, the reality eludes dualism and involves complications that require both the use of the arts and the harmonization of the arts. We must find a solid point of departure: liturgy is an art, but which art? It is important to know what the liturgy is, in order to understand its relationship with the arts.

LITURGY AS ART

In the distinction between "usage" and "harmony," an important point is raised: liturgy has a source. Its origin does not come from itself. It is not a pure creation dreamed up by the genius or the inspiration of a producer or playwright. Again, if it is not an improvisation or an innovation, is it perhaps an adaptation, as for example one might adapt a novel to the cinema? Is it then a reconstruction?

In Search of the Agent

For a long time, reflection on the liturgy has been linked to an analysis of the origin of this word which derives from two terms: a people (*laos*) and a work (*ergon*). There are two dimensions then: social space and work. In classical Greek the word signifies a pub-

lic function, a work or service carried out at the people's expense. So the meaning of worship has a certain feeling of a freely offered action.

The New Testament uses this term or similar terms derived from it a dozen times, eleven times in the Pauline works (five times in the letter to the Hebrews). St. Paul speaks of service (liturgy) with reference to the collection of funds (2 Cor 9:12), and of the fact that he is minister (liturgist) of Christ Jesus charged to serve the Gospel of God among the pagans (Rom 15:16). In the letter to the Hebrews, Christ carries out his priestly office, his liturgy (Heb 8:6; 9:21).

All these passages are well known. The liturgy is located at the crossroads of three realities: a person (the minister), a task to be carried out, and a people. Taking off from there, all possible combinations have appeared in history. Look at one example: if the people determine who is the person who will fulfill the liturgical role, it will equally impose its tastes upon the liturgy. The liturgy of the state Church during the French Revolution is a good example. Closer to the present, this is similar to the results that come about when a liturgical team imposes its taste on a parish. These relationships, linked to the etymology of the word liturgy, are important, even for the pastoral life of the parish.

However, posing the problem this way leaves it insoluble, since it is enclosed within the trilogy: person, office, people. Each term has some claim on power. But the real question has to do with the fact that every action presupposes an actor, every operation an

operator. Let us go back to history. There never would have been a public office, thus no liturgy, if there had not been a king to confer it. Classical Greece had very precise rules governing its different priesthoods. The Hellenistic world, closest to the New Testament, would never have thought of a liturgy without royal privilege or approval. The invisible but indispensable agent was the imperial majesty because it lay at the source of the public character or official recognition of liturgy. This explains the zeal of kings to show favor to a particular cult by constructing sumptuous temples, such as Herod the Great built at Delos.

This royal favor won kings the title of "Benefactor" (*Evergete*) cf. Luke 22:25, someone whose action (*ergon*) in favor of the people (*laos*) is good (*eu*): thus there is no good liturgy without the good act of an invisible agent (on this subject, cf. Wis 14:17-21). And Luke applies to Christ this quality of "doing good" (Acts 10:38).

For the Letter to the Hebrews, which is very conscious of the way in which the high priest of Jerusalem depended on the reigning king or on the Roman procurator, it is because Christ rose to heaven by virtue of his sacrifice and his resurrection that he has become the "minister of the sanctuary" (Heb 8:2), the unique agent of a unique sacrifice for a unique people.

This makes it evident that we must learn to identify the invisible Agent who lies at the source of liturgical action.

In Search of the Action

Having identified the agent, now we ask about the work in question. Here again the word is important. Since it is a question of art, we naturally think of a poem. But this word sends us back to the ideas of fabricating, making, inventing *(poiein)*: a poem is an invention or a creation. Liturgy is not a poem to be composed. More modestly, it is a work, an action. The work *ergon* is related to the verbs *erdo* (accomplish) and *rhezo* (doing): an action which accomplishes something becomes an event. The word *work* makes one think of energy.

Let us immediately suggest two implications: first, the liturgy requires craftsmanship; and second, the work of the liturgy is to make people into the people of God. Reflecting upon these two implications, we are led to a synthetic perspective: people are made to be a people by this craftsmanship of the liturgy. Just as faith grows by moving "from faith to faith" (Rom 1:17), so the liturgical act goes "from God's people to God's more deeply rooted people." The event that brings about this transformation, constitutes the special work of the liturgy. It brings about a conversion which moves us from beauty to glory.

Let me explain more about this exceptional work. The energy in question is "the immeasurable greatness of God's power at work in Christ when God raised him from the dead" (Eph 1:19-20). Possessed of this resurrection power, Christ "accomplishes all things according to his counsel and will" (Eph 1:11), "he is at work in us, enabling us both to will and to

work for his good pleasure" (Phil 2:13). This power is expressed in the believer by faith (1 Thess 2:13): "you were also raised with Christ through faith in the power of God, who raised him from the dead" (Col 2:12). "The only thing that counts is faith working through love" (Gal 5:6). We receive an energy which is the power of the Spirit (Gal 3:5); but we know that the Spirit acts in making us to be a body, distributing God's gifts that constitute the Body of Christ (1 Cor 12:11).

If we come back to the question of the content of this work that is liturgy, the following becomes clear:

1) it is for the sake of resurrection life,
2) it is transformation, because it is conversion,
3) its purpose is to bring corporate life into being, for it is building up the Body of Christ. The liturgy is an art of living.

Art is above all *savoir-faire*—a practiced ability. The art of living consists in knowing how to act. In the art of living, the goal is to make the human person truly vital. The work that has to be done is building the human; the human person has to be made authentically alive.

This work, this craftsmanship (in the sense of executing artistic endeavor) represents the great accomplishment of Christ: "I came that they may have life, and have it abundantly" (John 10:10). This is the work that Jesus accomplished in giving up his life and returning to the Father. His art of living is a journey, a Passover. In rejoining his Father, he spoke these

words, "I glorified you on earth by finishing the work that you gave me to do" (John 17:4).

Art wants results. The liturgy is an art by reason of the transformation that it brings about and the changes that result. Christ who effects his Passover in this liturgy invites others to follow. By the dynamic energy of this action, the liturgy expresses its efficacy. The invisible becomes expressed in visible ways because of the transformation that it achieves when Christ draws all things to himself (John 12:32). Christ is revealed in the act of converting and transfiguring. He introduces human beings to fullness of life. The liturgy proves false the phrase of Roland Topor: "for me a 'believer' is not altogether human. Believers are possessed of emptiness, even if a 'true' believer is possessed of a more vast emptiness."[1] But, on the contrary, John says, "from his fullness we have all received, grace upon grace" (1:16) and Paul (Eph 1:23) writes that the fullness of Christ "fills all in all." The invisible is made evident through its action upon us.

ART AND THE ARTS

Christ holds in his hands the ministry, the minister and the people. The purpose of liturgical action is for all of us "to come to the unity of faith and the knowledge of the Son of God, to maturity, to the measure of the full stature of Christ" (Eph 4:13). We have to clarify again that the liturgy is not only a celebration of what is already existing, but draws human behavior into action. It is not a mirror, but an event, an act, a *kairos*—a time for transforming encounter.

A difficulty immediately arises concerning the transformation spoken of: doesn't such a transformation come about exclusively because of intellectual insight? In the fourth century a theologian as subtle as Marius Victorinus thought that the clear understanding of belief would suffice without need of any water rite in baptism. So perhaps transformation can be brought about by a movement of the will? "Do something and in doing it make yourself," wrote Jules Lequier in the nineteenth century. Do people need ceremonies, beyond underlining their decisions with celebration?

Whatever the contribution of intellect and will, human persons are much more than what they make of themselves. Persons are not the measure of themselves, as though they could be divided into a measured object and a measuring criterion. Human persons are first of all what God does with them and in them. The person has been made by God; the human person receives the self from God. In the human, creation and covenant meet and interpenetrate.

Moreover, in the transfigured Body of Christ, creation welcomes the Kingdom. In "the excellent name that was invoked over you" (Jas 2:7), creation rediscovers its order and its logic. It is recapitulated by the Risen One. The liturgy renders present the unique activity by which the Kingdom emerges within the created order. Matter itself is slowly penetrated. Insofar as it is the earthly place where God's desire comes to light in the Body of Christ, the human body is the sym-

bolic site of beauty: "Your lovers are handsome because they earnestly desire You."[2] St. Augustine speaks in a similar way: "Let him be the uniquely desired one, he who is alone full beauty, who loved us even in our ugliness, in order to make us beautiful."[3]

Beauty seizes creation and snatches it from the realm of appearances to make it resplendent in its essence and full of meaning. Beauty is a passage to action, like birth. The arts are actions. Their powers and the energy of the liturgy necessarily come together, since the spiritual evolution of humanity is at issue. But these crossroads of the arts and the liturgy, are they harmony or contradiction?

From Duality to Symbol

In a certain sense, we are back to the earlier opposition between "usage" and "harmony." More or less, we know what is needed for liturgy: to allow the invisible to communicate itself. More or less, we can see that there are two paths by which liturgy can proceed to transcend itself.

Imagine that liturgy wishes to make use of the arts. On the one hand, it decides to ask from the arts everything that is the most sumptuous: flamboyant gothic architecture, tapestries to cover the walls, sparkling stained glass windows. Here is the luxuriance of the Baroque. Here is Marc-Antoine Charpentier and Mozart. "Nothing is too good for God." The intoxication of excess joins heaven and earth in a nuptial exuberance.

Yet the Cistercians refused architectural ornament in their abbeys, the Carmelites continued to sing on only three notes, and country parishes continued to use Plain Chant and the popular Noels. God is beyond the reach of created expression. This passion for stripping down, the desert of emptiness, allows exclusively the light of the Burning Bush to radiate.

Let us go on: liturgy is the transformation of a people. It addresses itself to people within their culture and their circumstances. It is something for today. We might make fun of some popular liturgical songs, but are they not a reflection of present-day sensibilities? It is not at all clear that relevance is a better criterion today than it was in the past.

Even today, liturgy witnesses to sources and to roots which arose in the time of Christ. Although liturgy has never stopped evolving, all historical evolutions of the liturgy translate the permanence of the foundational act so that it can appear to us as what it truly is—an *origin*, not merely a memory. Nothing is more contemporary than the source of a living reality.

The priest is also an ambivalent figure: he is at one and the same time a sign of Christ the Head, source of all grace, and also president of this present gathered assembly. He cannot avoid playing this double role as he moves back and forth between the altar and the ambo, the ambo and his presidential chair. Trying to choose between the two would not resolve the tension.

This duality, whose description could be pursued even further, frames a significant problem, that of

knowing if the liturgy functions as allegory or as symbol. Allegory is based on a direct correspondence between a literal sense and a hidden sense. The comparison of the vine in John 15 is an allegory where each concrete element calls up a different parallel reality: the wine stock is Christ, the branches are the disciples, the wine grower is the Father. Inside these correspondences there is no word play, no adaptation. The allegory is an equation.

Allegorical functioning in the liturgy obeys this rule of direct correspondence. Explanation, the history of the rites, and commentaries make their mark on the expression of the liturgical action. A scrupulous obedience to rubrics will lead to a ritual materialism. What is legally executed will have an immediate significance. The result is that such liturgies are legalistically perfect and humanly deadly, because their performance leaves no place for the present—this particular people, these human circumstances, this moment of time. Too tight a connection with the All-Powerful erases the immediacy of the present. This kind of celebration is only possible at the price of a deadly distance from the present, of a forgetfulness of the body and circumstances. This of course has consequences for the relation of liturgy and the arts.

In the allegory, there is a death (the allegory of the vine ends with the foretelling of the betrayal of Christ: John 15:13). The choice is who will end up being killed off by this kind of experience: the people or the minister?

Baroque excess is perennial: liturgically there is no difference between a Mozart Mass, a Mass of St. Hubert with horns and hounds, and an uninterrupted series of organ pieces or rock songs. All of these are concerts in the course of which Mass is celebrated. The priest disappears during a *Sanctus* which lasts throughout the entire canon (except during the elevation), while in military Masses there is added as well the trumpet version of Taps; or the people disappear, relegated during the concert to their private devotions. Or perhaps they are set to clapping hands and repeating refrains cried out over and over again. In all these cases the people lose their role.

Even extreme simplicity can lead to a similar kind of symbolic death: the celebrant like Moses on Mt. Sinai meets the Holy One alone, the assembly is allowed to disappear, and they are left with the choice between a sort of individual mystical elevation of soul or sheer boredom.

In any case, the corporate dimension disappears. The allegory demands a face-to-face encounter; third parties are out of place. Then allegory leads to a takeover by the celebrant or by the organist or by the cantor or by the assembly. Art oscillates between master and slave. The architect commands, or the music Or perhaps the lighting, the vestments, and the different ministers are wiped out. The key here is that liturgy *uses* the arts or, more subtly, *imposes* its harmony—it is all the same, because harmony depends directly upon the one who brings harmony about, who (alone) governs the activity. In such a perspec-

tive, there can only be conflict between the arts and liturgy. This criticism is sharply drawn in order to be clear. The absence of a corporate dimension is something to which we must be carefully alert. Happily liturgy acts not only as allegory, but as symbol.

Liturgy as Symbol

Returning to what was mentioned before, everything is summarized for us in the following words of Christ: "If I am not doing the works of my Father, then do not believe me. But if I do them, even though you do not believe me, believe the works, so that you may know and understand that the Father is in me and I am in the Father" (John 10:37-38).

Four factors are at work here and are brought together to create an ensemble. First, the principal agent is the Eternal Father who is the source and end of the action of the Son. The Father is the invisible agent (since "no one has ever seen God. It is God the only Son, who is close to the Father's heart, who has made him known" [John 1:18]).

Next there is the Son in his incarnate body, acting as minister through his human flesh. Then there is an ensemble of works—words and actions—which, arising out of his body, symbolize his own person. The person is expressed by the works he does. Finally there is a body to be built, that of hearers called to communion in a faith which transforms and unites them.

It becomes clear that the relations are all *mediated* and not allegorical. The Son reveals the Father in his body. The works of the Son allow us to know the

person of the Father through the Son, and the assembly are led to faith by the works of faith. Every direct relationship passes through a mediation. This is the way symbols work.

The symbol brings realities together that are different, distinct and separate. There can be no authentic marriage unless the man and the woman are different in gender. This bringing together requires a third reality which does not arise from the simple juxtaposition of two separate elements. In liturgy, simply bringing together the pieces of the ritual action will not guarantee a satisfying ensemble. The symbolic— the foundation of the union in difference—demands an attracting pole which holds the elements in communion and binds them together. A symbolic liturgy is the opposite of perpetual innovation, of spontaneity delivered over to the inspiration of the moment. If it is to have unity, it requires the ability to call upon the invisible as the foundation of its unity. The basis of the symbol is already present in each of the elements; it makes them exist. This is why it moves them toward one another even while maintaining their specific distinctness.

The question then is not choosing between exuberance or spareness or between "usage" and "harmony." What is at issue is not forcing unity, but creating communion. As an art of living, liturgy needs the arts. It needs to recognize them and bring them into play in their proper relationship to the mystery of communion.

FULFILLING THE MINISTRY OF LITURGY

As symbolic activity, the liturgy is concerned with *amplitude*. "The time is fulfilled," such is the first word of Christ in Mark's Gospel (1:15). The fulfillment of time does not come about by the addition of centuries or days. Jesus' words "it is finished" (John 19:30) do not come about from the accumulation of the Lord's acts. Everything is completed because he returns to the Father; this is his glory (John 17:1-15). The times are completed because Christ gives them their plenitude by being present to them: "For in him the whole fullness of deity dwells bodily" (Col 2:9). His body is the temple of fullness and fulfillment (Eph 1:23). This is an amplitude already present, but which we must open ourselves to receive and to bring into play (Heb 2:8). This is the role of the liturgy.

This fullness of Christ gives meaning to the roles which liturgical actors play. This fullness is the source of the encounter of the faithful with God as members of Christ's body. It draws to itself those who come, more or less aware of their reasons (John 6:44), since all creation is drawn to the One who brought it into being (Col 1:16). This fullness is brought into play by the celebrant.

Beauty as Movement

The beauty of a liturgy is invested in each participant of the liturgical assembly. In reality Christ as creator and redeemer is the reality that inclines each member to attend to one another. Every participant evokes the mystery that he or she is there because

saved, called (2 Tim. 1:9); their call extends also to others. The Christian at prayer is a living symbol of the Christ who calls people to communion. However, this communion in a vocation to worship needs to be animated each time the assembly gathers. It needs to be signified and to be made apparent as a special grace.

The arts are *par excellence* the favored place for the special and the unique. Beautiful actions are not repetitious. Each performance of a work of art is a risk—the risk of repetition, of routine, of the wrong note. Genuine art does not do well in serial performance. Repeated art can lose itself in self-fascination. But it can also rediscover the meaning of this God whose Name (*Yhwh*) is related to a verb which signifies: "coming without cease to the act of being"—a perpetual Dawn. Fullness is realized by unique and concrete acts. Academicism keeps looking back to itself. Beauty, on the other hand, is renewed in each expression. It always moves beyond itself. Liturgy redeems the arts from their self-fascination. It opens them up to a new amplitude, the fullness of redeemed creation. Likewise, the rites, the object of liturgy, surpass estheticism, since the action of worship has been given to the Church by Christ who acts within them.

As a result, we need to carefully make sure that each liturgical agent becomes fully alive. Paraphrasing André Malraux, we can ask not only if the twenty-first century will be religious, but if it will be human! The pipe organ has its legitimate place, so also the choir, so also the assembly. None of these is every-

thing, none has all the power, since the activity of each element participates in a symbolic whole which calls upon all the others.

To Create a People

We enter a church building through the vestibule, we pass into the nave by way of a doorway. Even those of us who know why we come to the church have to pass over the threshold. We do not come to find what we already know, like someone who is entering a department store. We come to hear the word of an Other who remains always beyond what we already know. We come to allow our spontaneous inclinations to be transformed. The threshold is not simply a place for entry. It is the space that opens onto the Other. The Word which invites us transforms us when we listen.

For this reason, an assembly is never created before the fact. In a sense, it is unaware of whom it will receive. The assembly is not nothing, but it has to allow its desire to be discovered, allow it to be purified, permit it to be directed. To create a people is to open up the structure of desire.

However, what often happens, is a glacial silence. For example, the organist begins to play two minutes before the hour and never has the time to finish the prelude. Then a rehearsal of some of the liturgical songs destroys the spirit of recollection, while preparatory activities around the altar likewise distract everyone. The church seems never to be ready to

receive people. The rites begin in conditions too bru-
talizing to allow the conversion of desire.

This same kind of awkwardness is true elsewhere:
three readings, the psalm, and alleluia flow on with-
out any chance to take a breath. The songs pay no at-
tention to the organ prelude, except for a few notes
which allow just enough time to find the right page.
All this fights against the education of the spiritual
desire of the assembly.

To make an assembly really come into existence, to
allow it to experience unity, is not the work of the
principal celebrant alone. Attention to the altar, the
light, the books . . . are all elements that create an
atmosphere when they are carefully prepared in ad-
vance. The word of greeting, the organ playing, and
the singing need to fit into a peaceful rhythm, but
one which is not sluggish. It is a matter of preparing
people for the radical act of listening by touching the
fullness that dwells inside each participant—a fullness
that hungers to be with others. So what we are doing
is not so much "creating an emptiness" as highlighting
the role of desire.

Celebrating an Event

Liturgy is a journey marked by a rhythm, like the
journey of the pilgrims to Emmaus. They pass from
misunderstanding to recognition, from hearts bitter
with disappointment to hearts burning within them-
selves, from eyes closed to eyes opened. And when
they finally recognize him, Christ propels them even
further beyond their own concerns. The event to

celebrate this is Easter, the dynamic force which carries us forward to communion with the whole Church and sends us out to proclaim the Word to all the nations (Luke 24:47).

The quality of liturgical action does not depend only on the artistic sensibility expressed, but on the depth of the conversion of those celebrating. Have they been touched? Have they set out on the journey toward the Easter mystery? We cannot scratch out the factor of the participants' sincerity. Popular liturgy is not a bargain with the least common denominator, but a liturgy that helps people to move toward conversion.

Movement toward conversion is the real object of liturgy. This is how it makes people to become "a people," creates them as the people of God. The real question is not if this liturgy pleases you, nor even if you find it beautiful. The real question is whether the liturgical rites move people forward to walk with God and to move toward God. Here we can recall the ancient definition given to beauty: "the beautiful is fruitful and productive." A beautiful wheat field bears a rich harvest. This kind of beauty has the weight of incarnation and the lightness of transfiguration. One breath of the Spirit is enough to bring everything alive—even clay.

We often require volunteer ministers in the liturgy to have not only good will, but also some qualification for what they do. Yet, the technical skills that they try to get through workshops and other processes of formation fail to address an important

and sensitive quality. The arts are not only *technique*; they require *freedom*, because they deal with spiritual desire deeper than what is immediately apparent. If sincerity is not enough, as we said before, neither is technique or information. Each liturgical player—celebrant, organist, reader—must witness to an inner truth, a capacity to receive a word from outside themselves which brings them to life. Each player needs the authenticity of every other one. Worshipping people are beggars. Because they know their poverty, their liturgy becomes the praise of that One who gives them everything. Liturgy succeeds when those who celebrate realize that they have been pushed beyond themselves, whatever their natural abilities or their skills. And they find themselves accompanied by the Unknown One on the journey to Emmaus.

In the Bible beauty is an ambiguous reality. It can either evoke the glory of God or represent a trap in which the journey forward becomes bogged down. Beauty is only revealed in the course of an exodus or journey. This is because beauty is transfiguration through which human beings become icons of the glory of God:

> And all of us, with unveiled faces,
> seeing the glory of the Lord as though reflected in a mirror,
> are being transformed into the same image
> from one degree of glory to another;
> for this comes from the Lord, the Spirit.
>
> (2 Cor 3:18)

NOTES

1 *Libération* (11 February 1991).

2 Hymn 35 on Virginity, v.12, in *Ephrem the Syrian: Hymns*, trans. by Kathleen McVey (Mahwah, N.J.: Paulist, 1989) 419.

3 St. Augustine, *Sur Saint Jean*, x, 13.

CHAPTER
TWO

Artistic Expression
in the Church

Artists and liturgists find themselves together with
some regularity. They both attend various colloquia,
conferences, or conventions (such as the one that fur-
nished the occasion for this chapter). No less regu-
larly, although with great caution, artists, sculptors,
painters, or musicians offer to the Church the gift of a
work of art or a project whose realization they
naively expect the clergy to sponsor. Such contacts
are often accompanied by grand declarations of prin-
ciple, although they usually make clear what everyone
already knows, viz., the relation between artists and
the Church is not altogether wonderful. A bit like
those interminable divorces where the definitive sep-
aration of the spouses keeps being put off and the
separated couples continue to meet, to write, and to
go together to celebrations to which they are invited,
the relation between artists and churchmen tries to
keep up appearances. Neither side really wants to take
responsibility for a break-down of communication, so

they maintain a semblance of mutual interest despite their evident mutual mistrust of each other.

Perhaps this comparison sins by being excessively pessimistic. However, let us extend the comparison for a moment and note how much the complaints hurled at one side or the other are similar to the resentment of a lover who uses every petty detail to complain, while avoiding the real issue. "Contemporary chants are inane and mediocre;" "the organist never takes part in the work of the liturgical team;" "Mass is celebrated during a concert given by the choir." The litany could go on and on. We look back to the past to find reasons to complain about the present. But enough of that

If we dare to face the difficulty for what it is, we see little that would sustain the dream of artistic harmony. Let us face facts: instead of taking for granted a harmony between the arts and liturgy as if that went without saying, we need to begin by admitting the hypothesis that the arts and liturgy are not naturally made to harmonize. We need to understand what the causes of discord might be. Let's admit that, some exceptional examples aside, there is a reasonable basis for disharmony. After examining this fact, we can then perhaps suggest how to get beyond superficial mutual discord in order to profit from common collaboration.

OBSTACLES TO THE MARRIAGE
OF THE ARTS AND LITURGY

I won't go back to the very beginning, but will limit myself to present-day issues. However, it is worth remembering the early mistrust of Christians toward the pagan cults, the "pomps" which we were asked to renounce at baptism. We remember that St. Bernard rejected the arts as influences foreign to Christianity. Before being brought into worship, the arts need to be purified or converted; so there also remains a cultural danger (similar to what we fear in marriages with "disparity of cult").

Yet we can still remember happier times when the arts and liturgy lived together with better understanding. Splendid memories of the past can easily hide the conflicts and the rivalries of the present. The passage of time makes things seem less serious. We now smile about past personal conflicts or quarrels between schools.

Without over-simplifying, we can explain a bit about our present situation. We have to keep in mind the social dimension of all the arts. Artistic activity is indispensable to a society. Artists express the spirit, the desires, and the worldview of an epoch. Their artistic expressions are based upon a social consensus which is present in the world around them, one that is reexpressed and affirmed, even enriched, in their artistic works. The arts arise out of the harmony between a society and its ideals. They express the transformation of the real into the ideal.

Since the end of the eighteenth century, this harmony has been thrown into discord: the earth and history belong to humans; heaven, the divine, and the supernatural belong to another order. This heavenly order is discovered either in the human feeling for nature or in individual impressions that touch the heart of each person. This initially imperceptible rupture gradually brought about more and more serious divisions. After a century, the earth would be placed in the hands of scientists and given over to the projects of technicians. Both scientists and technicians represent reason; religion becomes related exclusively to moral codes and ultimate ends.

In the midst of this division, the arts intervene in the debates of society. Moreover, they legitimate their interventions in the name of the sacred essence of humanity. Artists claim the right to express the intimate experience of what moves them at the center of their being, despite the conquests of science and the transcendence of religion. In speaking of what is the most intimate and secret, artists reveal what dwells in the depths of every human heart.

In this way artists produce a kind of self-affirmation of the artistic mission. The ideology of the artist evolves and becomes affirmed. Note how the arts become sacralized in establishing their independence. Artists who want to be free and unhampered depend on the divided condition of society, which leaves the field of artistic creation as a separate field for their solitude, prophecy, and emancipatory action. This subtle trap is linked to the arts, accentuating their

break with liturgy. Artists in this situation of honorable marginalization, even if they themselves may be believers, have difficulty in joining themselves to the social reality of worship, to the unifying act of the society of the Church.

Wouldn't it be appropriate to liberate the arts from this marginalization? Before deciding about this point, let us note that our hypothesis of discord between the arts and liturgy seems to be supported here, justifying the reservations expressed earlier. We need to clarify what the causes of this situation are, without prejudging but also without hiding the real difficulties. Three reasons explain the division.

The Arts and the Liturgy are
in Competition Relative to the Sacred

It is a rarely discussed fact that there exists a serious competition between the arts and worship. Once the arts were emancipated from the hegemony of culture, they progressively claimed an independence which allowed them to express everything about everything. The simple word "censorship" applied to a work of art—even a mediocre work—immediately confers upon it an artistic dignity that otherwise one never would have dreamed of giving it. The arts exist for their own sake. Let society or its representatives (not content to limit their role to simple support of the arts) express criticism, and artists will appeal to the absolute liberty of expression of their art. It suffices to say that the arts take themselves for absolutes, disengaged from every constraint, therefore from

every institution. Having become self-sufficient, they have sacralized themselves.

If the sacred constitutes a world unto itself, then its function and the rules of its expression are its own responsibility. Artists see open up before them an un-limited forum for any kind of daring or provocation. But this extension of possibilities arises out of the artists' subjectivity. The unlimited nature of the enter-prise shows the anarchy of subjectivity. With the awakening of self-consciousness and its notion of the individual (which Philippe Ariès has shown to be re-lated to concern about death) down to the age of the enlightenment and romanticism, through experiences both mean and grand, artists have never ceased to seek, to will, and to proclaim their independence. Their power comes from their isolation.

The liturgy also claims to deal with the sacred. Not only does worship establish a cycle within time, but it also marks out sacred space in buildings, shrines, and signs. From birth to death it accompanies the human person; it consecrates love, it blesses human activi-ties; it integrates the fruits of human work: bread, wine, oil, fabrics, architecture.

So there are two distinct activities which are pre-occupied with the same object—the sacred. Clearly, they do not approach it in the same way. Moreover, caught up in this competition, Christian liturgy does not appear from a human perspective to be in a win-ning position. For the sacred in which liturgy interests itself, far from being a natural, original, and raw sacrality (without boundaries or specificity) is a sa-

cred world channeled, modified, and shaped by the person of Christ. It is not the great *whole* of nature, nor the naiveté of primordial innocence, nor romantic revolt, nor a great passion for the future. The sacred mystery of the liturgy by necessity returns to the person of Christ, this "concrete Universal" of which Père de Montcheuil used to speak.[1] Entering a relation with Christ purifies the sacral by giving it a face. It particularizes it.

Do the arts and the liturgy envisage the same object, then? Do they speak of the same thing when they mention the sacred? It seems not. A supposed harmony between them is based upon misunderstanding: initial mistakes become responsible for serious divisions. It was worth this effort to unmask the earlier semblance of similarity. A continued examination of these difficulties will become both more off-putting and more illuminating.

Liturgy and the Arts
Disagree about the Meaning of Freedom

The first opposition between the arts and worship should not surprise us; after all, is it so easy for someone to accept the Gospel? The difficulty in question goes back to the issues of freedom and creation. The misapprehension arises if one makes reference to this phrase of St. Paul: "For freedom, Christ has set us free" (Gal 5:1). It is imperative to accept the role of a liberator—and why refuse it? We need such help.

However for the apostle to the Gentiles, this freedom once given needs to remain free and not fall

back into servitude: "Only do not use your freedom as an opportunity for self-indulgence" (v. 13), that is, to satisfy human interests alone. Paul immediately adds: "But through love become slaves to one another" (v. 14). "Being free to serve," that is the goal fixed by the apostle. It is a matter of becoming an icon of Christ, of the Christian allowing the Spirit to progressively fashion the glorious image of the risen One within the person (2 Cor 3:18). The proper object of the liturgy is defined in this way: to heal persons of their servitude to the elements of this world (Gal 4:3) and to have them put on the splendor of the Son through the action of the Spirit.

The arts do not pursue a similar goal. Artistic freedom imagines that it confers the power to become its own source. Its will is determined by itself. Artistic activity is attached only to representations—some figurative that imitate nature, others abstract, emerging from the depths of consciousness. Anything appears possible or imaginable. The arts are intoxicated with their capacity to exhaust possibilities, to roll back limits, or to invent new horizons. All this lies within the power of artistic imagination. Artistic freedom belongs to this world for which it provides images— unified or broken, peaceful or disturbed, classical or revolutionary.

Icon or image? The first opens us to otherness and expresses the invisible within the visible (see the Preface for Christmas); the second serves as a mirror for this world from which it takes its perspective. From the time of the Bible's prohibition to make im-

ages (Exod 20:4) down to the misgivings of St. Bernard and so many other Christians, this tension has existed between liturgy and the arts. On the one hand, liturgical freedom seeks to take its distance from this world. Liturgy depends on the world certainly, but so as to welcome within it the One who comes. But on the other hand, artistic freedom makes use of the world to express its own creativity. Yet is God not the creator of both worship and the arts?

The Arts and Liturgy
are in Conflict with Respect to Symbols

Following the first misunderstanding, the conflict becomes deeper. Reference to God as creator has often served as a way of pairing up the arts and worship. Further, the arts often found inspiration in the idea of creativity, just as liturgy found majesty in the same idea. However such an interpretation does not sufficiently recognize how these two forces are opposed.

In fact, the unbelieving artist is quite at home in a world abandoned to purely natural qualities. The arts can exist without reference to a creator. Furthermore there is nothing to assure that the work of an artist who happens to be a believer will express the quality of a Christian art if the artist is not explicitly attached to producing a religious composition. Artists possess the world in an autonomous fashion, in a way different from scientific types; but it is not clear that either favors the world of faith by the kind of the activities in which they are engaged. The product of science is

technique and the product of the arts is a worldview where the consciousness of the artist is the norm of the symbol. The arts are no exception to the norms of a secular world.

Note as well the revolutionary and critical dimension of the arts which envisage a horizontal future achieved through a projection of will power. Grasping this sense of the arts as a willful production of a new world, we can understand how little importance the creative past has. The secularization of our society levels symbolic reference exclusively to the productive imagination of an individual agent.

Liturgy clearly functions in a different way. The world where it acts is a world vividly aware that it receives life from God and that, in response, it offers itself to God. Its movement of praise explicitly recognizes God as creator and as savior. Such differences between worship and the arts are found at every turn.

Artists are masters of their work and of their signs. They have rights over the reproduction of their work. They can become culture stars. On the other hand, the liturgy serves the sacraments but is not their master. The source and Author of the liturgy is the Holy Spirit, not someone who celebrates (whose name could easily remain unknown). Visible liturgical action is exercised by an assembly of sisters and brothers, the people of God, not by a group of specialists. The artist is free to innovate, but not the celebrant who receives from the tradition the christological source of his activity. When the liturgy innovates, it

goes back to what was given to it by tradition. In a word, mastery of liturgical symbolism does not belong to the priest but to Christ. The Church's memory is deposited in the Spirit; liturgy belongs to the Church. It is rooted in the communion of the Church with Christ and, through him, among the faithful.

By an astonishing sequence of historical considerations, after a long period when the liturgy was the patron for practically all artistic activities, and then a following period in which the arts claimed their autonomy, we now find ourselves in a situation of mistrust, perhaps even alienation, comparable to the situation at the beginning. This quick analysis permits us to be a bit more precise about the object of the conflict: it is a matter of knowing who—the artist or the liturgy?—is master of the symbolic dimension. Is it artists who freely use the symbols of their choice—biblical, Greek, third world, pantheist, or other—to introduce visual themes into the Church? Or is it the Church which commissions from artists not the execution of specific works, but works that express a symbolic dimension? Hidden behind the interminable debates about Christian art is this deeper question of hegemony. Christian art would then be an art which recognizes the hegemony of the faith in using its symbolism and giving signs of an obedience of faith. By obedience, we don't mean the annoyances of an Archbishop Coloredo in Mozart's life,[2] nor some other kind of clerical dominance, but rather a profound listening to that Other whom St. Paul spoke of in Romans 1:5, "the obedience of faith."

A number of present-day conflicts may be ex-
plained in this way. Why have church choirs been
suppressed? Putting the best face on things: in order
to make the whole assembly sing. We find current
church hymns inept? But let us at least note that their
words have a more profound biblical inspiration than
those of a previous period that were often effete and
moralizing. Many modern liturgical rhythms are un-
fortunate perhaps, but how many parishes of yester-
day actually succeeded in an honest use of Gregorian
chant? It seems to be the case today that the smallest
town is able to find money to build a festival hall or
public theatre while a diocese searches in vain to find
money for a cathedral. These are four examples that
may be debatable, but they are significant in illumi-
nating the question of the control of symbolism. Even
if my description is not altogether satisfactory, we can
note a certain transposition of symbolic dynamics.
The new emphasis is on the people of God rather than
on specialists who express themselves in the place of
the people, on the Bible before any other considera-
tion, on creating a warmer and more engaging envi-
ronment rather than warming up nostalgia for the
past, and finally the emphasis is on poverty in the
place of lavish celebration.

I willingly recognize that there have been excesses,
errors, outrages, and impardonable rapidity in making
changes, and often this has been marked by power
struggles. Think again of the old couple for whom ex-
aggerations about annoying details serve to hide their
alienation and put off posing the question which

brings this analysis to a conclusion: Is there not a
radical divorce between liturgy and the arts? Excuse
my being audacious enough to ask the question! It
seems useful at least to say this: If this is the situ-
ation, in place of continuing to dream of a sponta-
neous and unanimous harmony, we can face up to the
divisions and differences, leaving us free to finally ask
under what conditions the marriage between liturgy
and the arts might take place.

THE CONDITIONS FOR A MARRIAGE
BETWEEN THE ARTS AND WORSHIP

Any marriage must begin with the insurmountable
distinction of a difference, namely, the difference of
the sexes. To this is added differences of age and cul-
ture, which may favor a common life or not. Because
there is such difference, there can be the possibility
for union. Love is nourished by such differences.
Separateness may hold a promise of unity, but only a
promise. Thus between liturgy and the arts, far from
there being only misunderstanding, there is also the
promise of integration.

The Promise of Encounter Between the Arts and Liturgy

Let us go back for a moment to the letter to the
Galatians which was probably written for Christians
some of whom came from Judaism, others from pa-
ganism, and still others who came from paganism
passing by way of Judaism (the proselytes). In the eyes
of the apostle, their situation is identical: they are all
equally bound up in a world which holds them pris-

oners to the imagination of the surrounding culture, enslaved to the elements of this world (4:3) or enslaved to false gods (4:8). The world is a prison made by humans and which humans have made to their own image. So "although they knew God they did not accord him glory as God or give him thanks" (Rom 1:21). Human creatures need to be freed, saved from themselves, from what Paul calls "the flesh." Sin consists in consenting to something that cuts off one's relation to God and colors it according to the passions of the human heart.

In this hopeless situation, God takes the initiative in three ways. A divine initiative is something history is unable to produce but which, arising elsewhere, breaks into history. The first initiative concerns the promise made to Abraham to give him an inheritance and to bless in him all the nations of the earth (Gal 3:8). The second initiative is God's giving the divine word as law to lead believers to Christ (Gal 3:24). Finally God sends his Son to allow humans to become children of God in the Holy Spirit (4:4-7). History is not abandoned to its own resources or allowed to sink into the absurd. Beneath the superficial convictions of the world, revelation provides meaning that gives us both an orientation and significance. Human beings are called to become children of God and creation is destined to be integrated by the Son of God into a divine plan (Eph 1:10). The world is snatched away from absurdity. The world's charms no longer seduce the human heart, a fascination which the book of Wisdom sees as one of the sources as idolatry

(13:3). The incarnation of the Son exorcises the charm of worldly things by reintegrating them into the design of the Father. It delivers the human heart from the trap of narcissism (Wis 14:15) or from the flattery of power (Wis 14:17). Instead of being closed up in their own world, human beings are open to the world of God which has become accessible to them.

The whole universe has received a promise, an attraction toward this new birth in God. Human beings incessantly discover themselves faced with a radical choice between being contented to hold on to what they can grasp or allowing themselves to be drawn toward the Father. The arts are faced with the same choice. Like every other human activity, they need to be liberated, to be saved from any tendency to be closed in upon themselves, to be self-satisfied.

Along with this theological orientation must go conversation about God's splendor which provides us direction and energy. The Book of Exodus (34:29-35) describes the radiance of the glory of the face of Moses when he came down from his meeting with God. This God whom no one could see and still live (Exod 33:20) communicates to his servant Moses a reflection of divine beauty, to the point that Moses has to wear a veil over his face. God's beauty is both revealed and hidden, both shadow and light of this God of the Exodus. Moses' frustration was to be someone who radiated a glory that he had been able to approach only from behind, similar to the brilliance glimpsed by artists that is beyond their power of expression, like an inaccessible and untouchable

grace. Attraction to such beauty inspires all lovers of the arts. But toward what is this attraction directed? It is a great thing to feel the profound power of grace, but little comes of it if beauty, like an indomitable fiancé, flees away once glimpsed.

Within this desire for grace that constitutes a promise for the world, a convergence between the arts and liturgy can be discovered. They are not so separate that they must become incommunicable strangers. Like the difference of the sexes that orients male and female toward one another, the distinctions between liturgy and the arts, once recognized, can become a desire for encounter. Created in the image of God, humans are oriented toward God. The human person does not always know this, even if he or she feels the force of some attraction. Yet liturgy sustains a lively awareness of this mystery which makes it able to decipher for the human heart things it sometimes cannot understand. The Council of Orange of 529 put the matter this way:

"If humans possess some truth and justice, this comes from that source for which we thirst while in this desert: moistened by its drops, we do not faint away on the pathway."[3]

Thirst asks for water, even if it does not always find a source for it. The liturgy's conversation about God's splendor offers living water. The God whom no one has ever seen is revealed in his unique Son (John 1:18). After the death of Jesus on the cross, John gives us this description (19:37): "They looked upon the one

whom they had pierced." Splendor is allowed to be seen in the nakedness of its self-offering. Already his Breath has been returned into the hands of Father (19:30). In his death Christ blazes the pathway toward God. Beauty and glory come together, transporting humanity into the infinite mystery of God who, in giving himself, transforms those who receive God. St. Paul understood this well when he referred to the veil of Moses in writing to the Corinthians, a veil no longer relevant, torn away like the veil of the temple: "All of us, gazing with unveiled face on the glory of the Lord, are being transformed into the same image from glory to glory, as from the Lord who is the Spirit" (2 Cor 3:18).

The special role of the liturgy is to communicate this glory. This purpose also indicates the limits of liturgy; liturgy does not do anything it wants, it rather serves the sharing of a mystery. And both words are important: "sharing," for liturgy does not celebrate an unreachable God, nor an anonymous surrounding nature; rather it proclaims the One who communicates the divine self in an eternal and unique act. Also "mystery," for the God received and known is inexhaustible and infinite, and must always be welcomed again, always discovered again. Liturgy is at one and the same time the most gratuitous of acts, since it proceeds from pure grace, and the most open, because it is pure encounter. Liturgy is an act of purity: "Blessed are the pure of heart, they shall see God" (Matt 5:8).

The promise of a marriage between the arts and liturgy is oriented thus. But we still have to address

the inadequacy of this nuptial imagery because of the unequal condition of the two partners! For if the arts, along with other activities, express a transcendence of the human and an attraction toward the infinite, liturgy brings to humanity a healing of its deformities and gives it the image of a splendor glimpsed. The arts need to be baptized to be united or integrated into the liturgy. Artists who are unbelievers might figure out the orientation of the liturgy, but their works only become liturgical when their symbolism enters into the liturgical action that allows God's presence to penetrate the world. The crucified one who holds the world between his two opened hands, presents the liturgy to the arts a bit like God presenting Eve to Adam. God alone can join opposites, wrote Nicholas of Cusa. Speaking of joining, then, presupposes a reconciliation.

The Reconciliation of the Arts and the Liturgy

Making promises without bringing parties together is useless. Where can such a meeting take place? It must be situated in some sort of transcendence. The arts only represent the world as they know it. They represent it and transform it by their work, through effort or through talent. People who dance give witness that they are not just flesh but also movement, tension, and desire. They do not live exclusively by flesh, and their bodily movement proclaims that fact. The arts make a statement, then they step back. What flows from artistic action does not speak exclusively of itself nor of its effort; it can evoke our innermost

depths, what lies *beyond* the immediate and the tangible. The arts are "transforming." They speak about the human and about the world, but as changed.

By comparison, the liturgy is "transfiguration." In liturgical action, the Spirit "pleads in sighs too deep for words" (Rom 8:26). The Spirit speaks and acts, but in order to express the ineffable—to say "God." The Spirit sings a world made new, giving us in our hearts a first installment of the divine reality (2 Cor 1:22). The true effect of a liturgical celebration escapes human calculation since it takes place in the conversion of those who take part, in their reconfiguration to Christ. In the liturgy each participant becomes an artist, called to make an *objet d'art* of their life, and to make of the assembly "a fitting testimony" (1 Tim 6:13).

Transformation and transfiguration: there are seeds of otherness in these changes. Artists abandon a simplistic relation to the world; the liturgy sets out for the desert to discover there another—the Other. Let me give an example. In the theater, the actor has to "forget" the script if he or she wishes to be free and to remain faithful to the text. This stepping back is the shortest pathway to the heart, to the essential. So the role for liturgy is not to sketch a picture of the world as it is. Rather it is called upon to discern the divine future for the world in order to take part in the work of recapitulating the whole universe in Christ (Eph 1:10; Heb 2:8). Music for the Church, whether by Rossini or by a rock group, only becomes liturgical by taking a certain distance from secular music. This distance is required by the very nature of liturgy: its si-

lence, its fidelity to the word of God, its communion with all the faithful. This distance requires as well the formation of an interior stance which expresses what is at play in liturgy. These are factors by which liturgy works on the arts to the point that they become transformed, without paradox, into an integral part of the liturgy. The arts are no longer left in their solitude, left to their self-emancipation. Liturgy frees the arts from their "artistic absolute." Liturgy forces them to redefine themselves. Far from the sad opposition detailed earlier, there begins a common work of the arts upon reality and of the liturgy upon the arts. This is the basis of their collaboration.

Unquestionably, liturgy needs the arts. We can't conceive of liturgy without the arts. There are two reasons for this. First, liturgy deals with human beings as they are in the present world. It reaches out to them not only in their superficial reality but in their fullest cultural development, which the arts have the function to express. Second, liturgy makes present a transfiguration of this world that the arts attempt to evoke, each in their proper manner. To express and to transfigure—these are the points of reconciliation where the arts and liturgy must come together.

But this courtship has serious difficulties to face. If we say that the liturgy works upon artistic efforts, what artist is going to accept such an onerous burden? To serve the liturgy in such a way, is this not to renounce the creative freedom that is at the heart of artistic inspiration? Without lingering further, let us immediately note that the priest renounces himself in

so far as he is presider; like the actor, he "forgets" his script and his personality in order to make his role a living reality. Faced with the refusal to be "at the service of the liturgy" so as to insist upon one's autonomy, we propose another refusal: the refusal to renounce this service. Put this way, we can find liberation from narrow and partial allegiances. This is what I mean in saying that liturgy can free the arts from themselves.

How Liturgy and the Arts Can Live Together

A harmony between liturgy and the arts depends upon Christian symbolism, upon the liturgy's need to signify, evoke, and make present its conversation about the splendor of God. Liturgy inscribes within time and space signs of God's unique, eternal project of inviting human beings to partake of divine life. In this sense, the liturgy expresses its fundamental meaning as the source and summit of all Christian activity.

Liturgy provides the foundation for a great variety of artistic expressions: architecture, music, sculpture, stained glass, weaving, painting, jewelry-making. All these draw from liturgical action motives for artistic creation which vary according to time and culture. In fact, it is not this aspect of the problem which causes the greatest difficulties. An architect has never refused to build a church, nor a sculptor to carve a statue. The real difficulties begin with another aspect of the question that touches the way in which the arts are called to serve the liturgy, rather than serve themselves. How can we know if an artistic work fits into

the work of worship? It is not enough that the work expresses religious subject matter for it to find a place within worship. A catechetical illustration is not an icon suitable for a liturgical procession. There are, I think, four criteria that can be put forward here.

A Liturgical Work Serves Liturgical Action

By nature, liturgy is an action, an initiative taken by God toward human beings and a response by human beings moved to open themselves to God. There have long been comparisons made between liturgy and theater. But theater moves from the stage to the outside, toward spectators, whereas liturgical action comes from the outside (like a procession) to move progressively closer and closer to mystery. Liturgy allows itself to be penetrated by mystery. Its celebrations always remain an entering, a movement. According to an old word used in theology, liturgy is *mystagogical*, that is advancing toward a mystery. So the faithful are initiated *by way of* rites, rather than initiated *into* rites. What the rite celebrates, reveals to believers that an invisible Actor transforms them.

From this theological comment some practical consequences follow. For example, a church, far from being a multi-purpose room or a space for theater, controls its sacred space according to this notion of progression: between shadow and light, between the entryway and the sanctuary stands the altar as the central point. We should be able to move about it, to rest in meditation near to it, to make a circle around it. Church ornaments support this pilgrimage: statues

should not be isolated for devotions to a particular saint, rather they should support the movement of the faithful toward the altar. The capitals of the pillars, the stained glass, the paintings—none of these are placed by happenstance, but should be related to one another in a way something like that of the stations of the cross.

When each piece is in its proper place, in an order which leads the believer from the front door to the altar, then all these works of art speak for themselves. They make sense when their size, their simplicity, and their appropriateness show them to be meaningful. We don't expect to be able to see the embroidery on the liturgical vestments from the back of the church. But likewise how can we make it clear that baptism belongs to a Christian's entrance into the life of the Church if the baptistery is found at the foot of the altar? It belongs at the place where one enters the church building! In the same way words, commentary, and chit-chat fill in for the lack of aesthetic order when the objects in the church have lost their harmony. When a sacred object is not in its proper place or when it is in competition with something else, such elements mutually cancel one another out in place of mutually supporting one another. Losing real liturgical signification, such things become useless. A church building is emptied of meaning when it has lost its logic. There is a liturgical order, a way of arranging things which makes for a celebration where a kind of logic controls each element that contributes to the liturgy—the music, the lights, everything else.

Liturgical action is not preoccupied exclusively with the value of gestures and words. Sacramental theology has long defined the conditions for the liturgy. Even when celebrated by an incompetent or unworthy priest, a sacrament remains a sacrament of Christ as long as the requisite conditions are respected. But look at the central act of our salvation which is the cross. It was announced, prepared, explained, and symbolized even before being celebrated; so this environment where Christ is received employs the riches of this sacrifice and introduces believers to it. In a similar way the quality of the celebration of the sacraments contributes to the meaning of the sacramental act—what it says, what it reveals, what it allows people to understand. A beautiful gesture expresses mystery. This is why, in order to give liturgy its full meaning, worship needs the arts so that it may express itself in its fullness and its splendor. The arts teach the liturgy how to make beautiful signs. What do they bring to liturgical action? Not directly the truth of the incarnation which is God's gift, but rather a penetrating understanding of the human condition where the incarnation was expressed. The arts help liturgical mystery to become visible and effective.

Liturgical Action
Is Shot Through with Renunciation
Allow the liturgy to express itself. In all its simplicity, this formula demands nothing less then a shocking renunciation on the part of artists as well as on the part of liturgical ministers. First, by entering into the liturgy,

artists abandon personal singularity to participate in a unified ensemble. Liturgical action does not allow anything like this: At the organ today we have Maestro X; then, directing the choir in music by Z, we have Madam Y; the chasuble of the celebrant comes from company W, Mass is celebrated on an altar made by V, and Father so-and-so will celebrate the Mass today. No, liturgy does not name any other actor than Christ. Before a Romanesque façade, who points out the carved top of a pillar on the clock tower? It is there, that suffices. Faced with the action of Christ, what is the value of our human works? Our reputation? Our style? Christ recapitulates everything in his unique work. Liturgical anonymity is only a reality in *our* eyes. For the Father sees in secret (Matt 6:4): "To everyone who conquers . . . I will give a white stone, and on the white stone is written a new name that no one knows except the one who receives it" (Rev 2:17).

God alone knows the invisible splendor of any human person. Liturgical anonymity celebrates the secret beauty of each person.

Here again theology offers consequential insight. Every liturgical object, every artistic action, enters into a unity. The choir does not replace the assembly, but supports its prayer; the organist does not show off in such a way as to destroy the movement of the liturgy; the light does not blind the congregation (I am thinking of a huge window located just in back of an altar where the brightness from the outside blinds those in the church, making it impossible for them to see anything). A liturgical ceremony is teamwork:

music, singing, readings, flowers, lighting. Each has a unique and indispensable place, but its quality is judged in terms of the ensemble. This represents a shocking renunciation of individuals' willfulness. It demands a constant adaptation to the liturgical season, to the needs of the celebration, and to different types of congregations.

What else can be said on this theme of renunciation? We noted before a movement of abstraction, moving toward a stripping down, leading to poverty and aesthetic nothingness. Artistic death lies down that road. But true liturgical poverty is a path of transfiguration. Done right, it strips down in order to allow itself to be remade by the beauty of God. Its openness is a self-offering to the work of the Holy Spirit, a pure desire for the Other.

This kind of poverty corresponds to one of the needs for good celebration. Liturgy draws people together, based on the common ground of baptism, without choosing who they will be. The principle for gathering them does not come from taste or from aesthetic inclination, neither does it come from an aptitude for singing well. Deaf and dumb people also have a right to liturgical celebration. The people who gather for worship are brought together in the name of their faith—be it little or large—and even more they are brought together by the faith which is offered to them by the Church. It is these people, just as they are, who have to be made attentive, receptive, and open to God. Celebration requires us to begin again each time teaching this openness. Helping a

people to pray—that is everything. Every element is brought together for the sake of this service and renounces itself in favor of this work.

Liturgical Action Is the Action of the Body of Christ

I mentioned above a parallel between our time and the time of the first Christians. This parallel holds for another point. In periods when the majority of people were Christian, it was permissible to develop private devotions leading to the multiplication of chapels, statues, and paintings within the church. There was no risk of conflict, since their belonging to the Church went without saying. Private devotions represented a certain way of being in the Church.

Our present situation has changed all that. We have to reaffirm today, as in the first ages of the Church, the essential basis for our life together. Liturgy is an act of the ecclesial body of Christ in which "we are the members of one another" (Eph 4:25). The Church is the People of God, the Body of Christ, the Temple of the Holy Spirit, the Spouse, the Mother: so many titles to penetrate to the heart of its mystery.

Within this communion, each believer receives much more than sincerity; they receive the truth. The most humble person who recites the Our Father, speaks the truth. The beauty of this truth is that it is Good News.

It would be a terrible mistake to use the expression "People of God" (which should not be isolated from many complementary titles) to justify a kind of least common denominator idea of the Church, as if liturgy

ought to try to please an assembly with the most un-sophisticated taste. In the liturgical assembly, worship is not just a representation of the social reality of those present. Even in this life, liturgical action makes the Other present. This is once again a decentering, which begins with the assembly gathered together today in this place, but moving toward another place, toward a transfiguration, because the savior who invites the assembly comes into its midst. Liturgical action does not magnify the assembly in the manner of a circus mirror. The liturgy is always reaching out toward the Other. Even in the Preface for the Dead, we dare to praise and thank God in the midst of human pain.

To serve an assembly is to permit it to evolve and make progress. Space is not defined exclusively by vis-ibility (think of huge Romanesque pillars), but by an aptitude for moving forward. A large theater is not ideal space for a church. A liturgical assembly ought to be able to identify functions and places, objects and signs; the altar is the first of these, then the ambo for the word, and then the gathering place. The assembly has a right to hear and to sing, a right to silence and a right to contemplation; it has a right to be welcomed and to be conscious of itself as a body. Why do we then try to create a liturgical assembly with broken down PA systems, broken chairs or pews, doors that squeak and liturgical chants unknown to the faithful or too often changed? It is not using a guitar that drives people crazy, but the amateurism of the player; it is not the organ which is annoying, but a repertory chosen carelessly; it is not the vocabulary

of the sacred books which makes understanding im-
possible, but the inattention of readers and their in-
ability to pronounce words.

To minister to your people means thinking also of
that person who wants to sit in the back; it is to think
of handicapped persons and their needs to get in and
out; it is to make sure that someone will greet the
congregation as they arrive; it is to make sure the
church is clean, and that the lectors can read with
power. There are so many little things that have to be
done by ministers "who have only done what they
ought to have done" (Luke 17:10). There is a wonderful
symbol of all this in the liturgy of the bishop. In pro-
cession, the bishop walks last. That is a way of saying
that he can go no faster than the person in front of
him who walks the slowest. That is a good symbol.

Liturgical Action Is Memory

The plastic arts play upon the sensibility and sen-
suality of the participants. The musical arts move our
emotions. Every period of history contributes its par-
ticular means of bringing about emotional reactions,
and the Christian arts witness to this great variety.
Striving to avoid both bathos and trendiness, the
Christian arts go along with the expressiveness and
feelings of an age. This is inevitable and healthy, and
the arts ought to be aware of the ways in which they
express the feelings of their own period. This is why
the study and the creative efforts of artists are so im-
portant. In our present situation, however, we have to
acknowledge that there is a huge gap between artists'

sensibilities and the Christian people. It is easy for those who are in the avant-garde to claim to be misunderstood geniuses and to treat people like barbarians. However, this attitude doesn't lead to a satisfactory situation. On the other hand, it is likely that the cultural transitions that we have experienced in recent years have led to a loss of appreciation for the symbolic world and led to a decline that has caused a lowering of awareness and sensitivity toward community and liturgical life in the Church.

Because liturgy is not time-bound, it is first of all an act of memory. Just as personal reminiscence floats in everyone's consciousness, so liturgical memory witnesses to our roots and our origins. In the Church this memory is the Holy Spirit (John 14:26). The activity of this living memory is symbolized in these words of Isaiah: "Your name and your memory are the soul's desire" (Isa 26:8).

Liturgical tradition expresses this memory. It is rooted in God's interventions in history, bestowing inexhaustible riches on all ages and on the whole universe. This memory does not particularly reflect the interests of the present time, but rather attunes people to their salvation. Note that the structure of the Eucharist reproduces the structure of Jewish meals, of which the Last Supper was one. Bread, wine, water, oil—all these transmit salvation history, which went before us and which surround us.

Clearly then the liturgy cannot be independent of a relationship with this holy memory. It is part of its very essence. Each age receives this tradition with the

responsibility to hand it on to the next. Certainly, it receives it in its own manner and following its own sensibilities. This has always been the case. Yet, while an age of history may invent new forms, it does not alter the content or the meaning of the liturgy.

The division between the arts and liturgy becomes critical when it is brought about by a loss of memory, that is to say when the arts no longer evoke the Christian roots of worship. It is not twelve-tone music which disturbs Christian memory, but the disfiguration of liturgical texts, the debasement of hymns, the amputation of psalms, disdain for the characteristics or ignorance about the capacities of a diverse assembly. Underneath such mistakes is hidden the desire to accept only the part that pleases, to choose willfully, affirming no longer the universal objectivity of a deposit of faith, but accepting only the subjective option for the dominant taste. But liturgy renews in receiving; it creates because it is receptive, since its role is to make present what transcends it.

But let's be reassured: the divorce between liturgy and arts has not been definitively decided. Today's crises teach us at least that using marriage as a metaphor does not fit. Simplistic pretence of harmony may leave the liturgy as the servant of its powerful spouse. There is a kind of weakness in liturgy (because of the constraints it must respect) before the force of certain influences. This congenital weakness is attributable to the One whom it honors. Yet this weakness makes liturgy free before all artistic currents. With freedom it is able to choose with what school it will unite it-

self, having in view only the service of worship rendered to Christ by his priestly people (1 Pet 2:5-9) and its "fitting witness" to the Lord (1 Tim 6:13). The servant lays down the conditions! It has seen the arts come and go.

However, the liturgy cannot bypass the arts because liturgy is about incarnation. Having come into this world, Christ leads it forward. Creation itself "groans with the pains of childbirth" (Rom 8:22). Christ has already begun to reintegrate all things. Liturgy does not make alliances with the arts in order to find compliant functionaries. Rather it communicates through them to be in touch with the searching, the hopes, and the distress of all human beings. The arts incarnate liturgy in the womb of the world. They help it to perceive that the Spirit is at work and that this Spirit is already transforming people's desire to experience God. The arts point out to liturgy the place where it must pitch its tent and dig its well, because that is where human desire is evident. In this sense the arts go before the liturgy, not as its proper expression, but to indicate the human aspirations which worship should draw together so as to baptize them in the Spirit and offer them to God.

NOTES

1 Jesuit Yves de Montcheuil died in 1944 at the hands of Nazi executioners. Henri de Lubac said of him, "He constituted a living bridge between Catholic thought and the modern secular thought to be found in the university world of today": Henri de Lubac, *Three Jesuits Speak*, trans by J. D. Whitehead (San Francisco: Ignatius Press, 1987) 16.

2 Coloredo was the Prince Archbishop of Salzburg to whom Mozart was engaged in service as court musician. See Wolfgang Hildesheimer, *Mozart*, trans by Marion Faber (New York, Farrar, Straus, Giroux, 1982).

3 *Sources Chrétiennes No. 353: Les Canons des Conciles Mérovingiens*, Vol. I, trans. by Jean Gaudemet and Brigitte Basdevant (Paris: Ed. du Cerf, 1989), 166-7.

CHAPTER THREE

The Shepherd of History
"The Times That We Create"

Some sundials carry an inscription which is a little shocking: "The hours fly, the last one kills." While this has the benefit of clearly making its point, its reminder of the flight of time can depress us with its stoic gravity. This maxim underlines the seriousness of life by forcing us to think of death. But this realism, despite its wisdom, hides something else often true, that periods of great calamity are often accompanied by great debauchery. If life is short, why not enjoy it? Facing the end of life doesn't guarantee the quality of life. Is the time that passes solid or is it evanescent? The answer does not come from time itself. Furthermore, such a question has become more complicated since the time of sundials and water-clocks.

A Changed Experience of Time

The rhythm of the seasons no longer parallels our felt experience. Air conditioners keep us from experiencing hot weather. You can have fresh straw-

berries at Christmas and oranges in August. Our interest in seasons is connected most of all with vacations. (We don't want to miss our train by failing to change the clock to daylight saving time.) Every business meeting devotes part of its agenda to setting a date for the next one. Businesses have planning sessions which have to take account of the dates of breaks in the school year (formerly called vacations). Furthermore, we shouldn't forget those who, either by taste or by necessity, follow another rhythm, living at night rather than during the day.

Time is complicated. The most insignificant project has to take account of several calendars; a family has to coordinate the needs of each member according to their projects. Conflicts are such that agendas fill up more and more in advance of the date of an activity. We are overwhelmed by the demands of time. Free time becomes more and more rare. When, however, people do have time, they hardly know what to do with it. Moving into retirement, even though it gives people lots of time, often delivers them into a period of suffering.

In our society, most people go along with this criss-crossing and entanglement of life rhythms. Those who don't obey, are "cases;" they are either rejected or envied, either misunderstood or pampered. This situation arises from a variety of factors. We are influenced by the international dimension of the economy, the rapidity of communications, the overwhelming surfeit of international news, and stereotypes of social roles. The use of time clearly separates

someone who lives inside this framework from some-
one who refuses to do so or is excluded from it. So
we have on the one hand employees, administrators,
government officials, and merchants. On the other
hand, we have the unemployed, the marginalized, and
the poor. Their situation is defined by the way they
use their time, namely, by an enforced emptiness.

There is still another category, monks and artists,
who have a different relationship to time. All of this
says that productivity controls the meaning of time in
a human life. Some people dream about establishing
an ecology of time. Without joining those who make
a cult out of the horoscope as an alternative calendar
or returning to sun worship or measuring our destiny
by the stars, we ought nonetheless to ask ourselves
how Christian faith proposes to explain the growth of
New Age groups in society for whom a relationship to
time, based on the way they spend their life, demon-
strates a special relationship to human values.

This is why I used in my chapter title the plural,
"the times." I speak of the times that we create be-
cause in fact we need to know who is in charge of
this great jumble of computations and temporal mea-
surements? Evidently there is some relationship be-
tween the harshness of the rhythms of social life, the
violence of economic competition, and this fascina-
tion of New Age sects for some form of complete ful-
fillment of the human personality.

A Shepherd in Crisis

When a pastor succeeds in gathering his flock (no hour is always convenient), he is often extremely busy and finds himself with multiple demands. "People only have the time they decide to take," we say. This is true, and it's important to remember since faith requires voluntary decision on the part of believers. So to "give yourself time" is to set priorities in your agenda ("some things have to be done!"). However, this phrase reminds us that "we will all take time to die." There are people, however, who objectively just can't take their time. When artists are in the full bloom of creation, very little outside of what they do counts: "time doesn't matter."

A pastor is another example of people who fight monthly and yearly with their calendar, yet he has to bring together people who "hardly have any time" and those who "have time to waste." The one type can never find enough time to do all the things that need to be done, the others have time on their hands. The latter know time as something broken up into little segments, if not empty and meaningless.

At the same time the pastor lives a liturgical rhythm which makes the year fruitful with the feasts of Christ, the expectation of Pentecost and the hope of the Kingdom following the Gospel cycle of "green Sundays in ordinary time." These ordinary Sundays follow the movement of the seasons. The sense of this liturgical experience is to express the period between the manifestation of the visible Christ, recalled in the liturgy, and the hour of his return, which the liturgy

also proclaims. The cycle of readings starts over again every three years, according to an ancient tradition. Liturgical time is not first of all that of a calendar; it is related to the calendar only secondarily because it is necessary to establish stages in the year. Liturgical time follows the story of Christ's life, just as the date of Easter follows the lunar cycle. Christ is the "Lord of time" (second hymn of None). The just one sings to the Lord "seven times a day" (Ps 119:164); that is to say "without ceasing" (1 Thess 5:17). The rhythm of praying seven times a day becomes a habit, a way of being. Scripture also says that the just one sins seven time a day (Prov 24:16), a way of indicating how deeply evil is able to upset the human person. The rhythm of prayer translates a state of being.

A sermon attributed to Apollinaris of Laodicea illuminates the timeless aspect of liturgy: "The year is a symbol of eternity, because turning in a circle, it returns always back upon itself and never stops at any single point."[1] The pastor receives the liturgical year as "a rich deposit—a rich trust from the Holy Spirit" (2 Tim 1:14). And what he receives, he must hand on (2 Tim 2:2). The liturgical celebration replicates this handing on of the faith. Christian initiation is rooted in sacramental action. So on the one hand, the pastor needs to remain faithfully in contact with the source of sacred time, which is the living presence of Christ and of his word and faith; on the other hand, he must transmit to very different kinds of people this same mystery, despite their different levels of faith and maturity. Liturgy chooses neither immobility as its wit-

ness to an age-old tradition nor, on the other hand, abandonment to all the influences of the present. But putting matters that way is inept, since liturgy is the source of faith life and the nature of a source is to flow. A source is not a cistern (cf. Jer 2:13). The liturgy imagines another way of putting the question.

RECOGNIZING THE TIME,
OF GOD'S VISITATION (LUKE 19:44)

"The times that we create," we said in the introduction. This phrase merits some attention. A train conductor uses all his skills to be on time. A train that is late is off schedule—unfaithful to the timetable. This supposes a timetable to follow, such as the Amtrak timetables which are all plotted by computer. The control of time is linear; the goal is to gain time in following the timetable.

This mentality has had its influence on liturgy. Let the celebration of the word go a little too long, and the celebrant will try to make up time by accelerating the Eucharistic Prayer. To make the point of this comparison, come with me and watch the following Eucharistic celebration. We make it a norm that a sermon can only go twelve minutes; Mass begins at 12:10, and a celebration is supposed to be over within fifty-five minutes, etc. I can understand why we don't want to unduly prolong a ceremony and why a preacher shouldn't go on until people can't stand it anymore. But I want to call attention to this linear control of time which has repercussions on the way we under-

stand the relationship between the source of liturgy and its actual celebration. Our fixation on the limit of a certain period of time and our mental urgency about something that just must be done in the future represent the twin consequences of this kind of linear thinking about time. Our mind becomes fixed on the past or on the future. Our frustration projects us out of the present into one or the other.

But liturgy works in another fashion. It follows another principle. It does not go along with horizontal linear time. It follows the *depths* of time; it looks for the *intensity* of time.

Time Pulls in Its Sails

Paul writes to the Corinthians (1 Cor 7:29), "the time is running out." He repeats this idea in saying "Our salvation is nearer now than when we first believed" (Rom 13:11). Christians are invited to wake up from sleep and live in the full light of day; Christians are "children of the light" (1 Thess 1:5). The brevity of time is indicated by a Greek verb (*sustellô*) taken from the language of sailors. Time "is pulling in its sails." Paul asks Christians not to imitate the world (Rom 12:2) and reminds them without ceasing of the importance of time: "Behold, now is the day of salvation" (2 Cor 6:2).

Just as a ship coming to port pulls in its sails, so time changes as it approaches its end. The unknown space which separates today from the day of Christ's return makes us think of another space—one that separates the present situation of the Christian from our full participation in the life of Christ. "Our inner

self is being renewed day by day" (2 Cor 4:16) under the action of the Holy Spirit. This renewal is described as a rebirth (Titus 3:5), a recapitulation of all things by Christ (Eph 1:10). History has reached its fulfillment, like a pregnant woman. The mystery kept hidden from the foundation of the world is now revealed to every-body (Rom 16:25-26). The times finally give birth to the Holy One who had been carried in its womb.

Because Christ is the fullness of the mystery of God (Col 2:9), because Christ is the one in whom everything has been created (Col 1:16), the time of fulfillment has come. He is the fullness of time (Gal 4:4), for in him the meaning of creation has been made clear. Creatures are meant to become children of God in the image of the Son. The first phrase of the letter to the Hebrews joins together many ancient interventions of God in history ("In times past God spoke in partial and various ways to our ancestors") to the eternal lordship of the Son ("God spoke to us through a son, whom he made heir of all things and through whom he created the universe") (Heb 1:1-2).

Jesus integrates within himself the linear move-ment of chronological time with the gradual emer-gence of the world's mysterious meaning in the depths of contemporary humanity. This is what is meant by the "last times" (Heb 1:2; 1 Pet 1:20) which bring about the integration of the present day with the eternity of Christ, "To him be glory now and to the day of eternity" (2 Pet 3:18). The New Testament mentions eleven times that the times have been "ful-filled." The life of Christ fits in between the phrase

from Luke that "the time came for Mary to have her child" (Luke 2:6) and the "It is finished" of his self-offering (John 19:30). The fulfillment of history comes from the fact that in giving us the Son, God permits us to receive the fullness of divine life (John 1:16). Christ fills the whole of history (Eph 1:23).

This fulfillment comes about in the incarnation of Christ. It is not a question of the evolution of human history, but of a gracious act of God "who has visited and brought redemption to his people" (Luke 1:68). The resurrection brings with it a renewal of every-thing—a new teaching (Mark 1:27), a new creation (Gal 5:15), a new covenant (Luke 22:20), a new hu-manity (Eph 2:15). Christians cast aside their old gar-ments (Matt 19:16), the old yeast (1 Cor 5:7). The Christian strips away the old self in order to put on a new self, a self "which is being renewed, for knowl-edge, in the image of its creator" (Col 3:9-10). Jesus turns "the time for the power of darkness" (Luke 23:53) into his Hour (John 17:1), into this *day* which is the day of the Lord (Jer 17:16). He is the judge of the times (Luke 12:54-55) because he himself is the source of renewal.

Liturgy gives us this time of grace during which we may put on Christ. A twelfth-century Cistercian wrote:

"I was going to allow myself to indulge a certain ex-cessive zeal in denouncing again the ingratitude and infidelity of our time, but once again the holy and blessed fullness of time of Christ reminds me of the

truth. This is the age of maturity and fulfillment of faith that the apostle calls the fullness of time."[2]

Time Spreads Its Wings

The time of fullness of faith is the Church which Christ presents to himself as "holy and immaculate" (Eph 5:27); it is recalled in this phrase from the Canon of the Mass, "Look not on our faults, but on the faith of your Church." Time has come to term. It is at its apex, the time for bringing Christ to birth has arrived. The same author quoted above, Guerric of Igny, goes so far as to say: "He who created you is created in you, and as if it were too little that you should possess the Father, he wishes that you should become a mother to himself."[3]

This birthing of God in a creation which "groans in the labors of childbirth" (Rom 8:22) will last until God becomes "all in all" (1 Cor 15:28), since at present not everything has yet been placed under God's command (Heb 2:8). Liturgy does not celebrate the birth of human history, but the coming to birth within this history of the One that it is not able to generate or produce, but whom it welcomes. Like the Church and like Mary, the liturgy is both virginal and maternal. It is maternal exactly because it is virginal—the One whom it offers has been given to it by the Father.

Liturgical time consists in the "now" of Christ who, opening his arms, enfolds the whole of history. History is seen here not under the aspect of duration, but rather as plunged into the heart of Christ who was given up for it. Time derives its importance from this

mystery. History is neither empty nor obscured, but given over to the process of bringing forth this Other. Experiencing time's intensity, "which doesn't focus on the passage of time," describes the liturgy rather well. Although it is celebrated within timetables, in fact it brings time back to its very source. It changes the "day to day" into an ecstasy, brief but profound, in the presence of God's Son who is the Heart of the world. Liturgy redeems time. In transforming time into a Christic phenomenon, it does not do away with the inescapable dimension of duration, but rather introduces it within an experience of love that is stronger than time. Duration has significance because of love's covenant.

Liturgy receives God to make God visible; it brings God into the world. It receives in order to create. Liturgical art has the qualities of both gift and creation. It aims to receive God's Presence. It prepares itself to receive and to concretely present the mystery delivered into its hands.

No longer does the fleeting quality of linear time control our experience; rather, the covenant "takes its time." This grace makes time precious. By conferring a special meaning upon time, it makes *this* time exist for us, and thus we enter memory and hope. The covenant recapitulates the passage of time by illuminating our union with the divine. This is the meaning of "the day the Lord has made" (Paschal Antiphon). "It is you who have made the past, . . . the present and the future; you were the one who conceived them" (Jdt 9:1).

The fullness of time does not exactly settle the philosophical problem of time and eternity. We are not talking here about the relation of the intemporal to the duration of time in the sense that this is discussed under the heading of "the one and the many." We cannot set aside the fundamental issue, namely, the eternal has entered time. This phrase allows us to offer some explanation about the philosophical issue. We must be sure, however, not to confuse the philosophical *eternal*, which is as anonymous as the *infinite*, with the face of God of which Christ speaks to us. For the mystery of time has not been opened up by philosophical argument, but by a divine act. Christ brings the old time to its end and becomes the source of the fullness of life. That is the *nature* of this eternity which is made present through personal experience of the Trinitarian God. The liturgy never ceases to praise the Trinity.

From this perspective we learn that liturgical time cannot be reduced to the emergence of eternity within chronological time. Rather liturgical time transcribes the Trinitarian economy itself within our experience of time, just as Christ lived his humanity according to his being as a Son. The liturgical act which arises from this mystery communicates the love of the Son who unites and distinguishes the Trinitarian persons. The mysterious economy at the heart of Trinitarian life establishes and nourishes a new kind of holy and unifying time that endures.

From this mystery the liturgical cycle arises, as the phrase of Apollinaris of Laodicea suggested, evoking

eternity not by abstracting from time, but in sustaining a divine initiative. The liturgical cycle follows the course of the year. It is fixed but renewed each time as a year of grace which symbolizes eternity. It renders the mystery contemporary, and "present now." The energy of this unraveling of time is the Holy Spirit. It is memory ("The Spirit will recall to you all that I have said," John 14:26); it is an act in the present ("The Spirit of the Lord is upon me. . . . Today this passage of Scripture has been accomplished," Luke 4:18-21); it is the future ("We are transformed according to this image . . . as is fitting to the action of the Lord who is Spirit." 2 Cor 3:18).

Thus the liturgy is founded as a new age, the age of the Spirit. This sanctified cycle exists within profane time so as to redeem it. It is not, however, indistinct. The reality of this "now" made present to us is realized in definite experiences, like those of Christ who benefited from the constant presence of the Spirit. As with Christ, there are "favorable times," a chosen Hour (John 12:27); there is the *kairos*—the precise moment of birth, of encounter, and of covenant. The year culminates in its feasts. Easter is the "feast of feasts;" Sunday plants the seed of the resurrection mystery every week. Of course there is the rhythm of preparing for the sacraments, of respecting the correct sequence of their rites. But we do not go from *before* to *after* without a moment of rupture, a *kairos* which implants within the year of grace the Hour of the cross on which all time revolves. The axis of the liturgy is rooted in the reality of earth and heaven en-

gaged as a crossroads. This is the new Jacob's ladder (John 1:51).

The pastor leads his people simultaneously through this unfolding of liturgical time and through this ascension toward God. This is a double movement whose unity is brought about by its similarity to the image of the Father, who is the Christ in the Spirit. The liturgy brings the hopeful course of sacred time to life thanks to favorable moments called *kairos*. They draw from the inexhaustible action of Christ who inaugurates the Kingdom. The Eucharist makes present the sacrifice of Christ and the banquet of the Kingdom. The memorial of the cross makes present the *eschaton*, the fullness of the Kingdom.

THE WORD AS FULLNESS OF TIME

The liturgy unfolds in acts and in words. The letter to the Ephesians mentions cleansing the Church by "the washing of water by the word" (5:26). The liturgical moment, this "favorable time" or *kairos*, expresses the word as both utterance and event as it acts within the Church. The word becomes a source of life by symbolizing itself in an action, and the liturgical act has meaning thanks to the word. This is why there are various layings on of hands used in the sacraments, in order to interpret the meaning of the word or of the silence (as in an ordination). Liturgical time is composed of an action (gesture) and a discourse—a double unfolding of acts and words which mutually empower one another. Acts follow one another, words are exchanged (as, for example, in the three-fold question-

ing in the profession of faith at baptism). The fullness
of time is translated into the word, *dabar* in Hebrew:
both event and word.

A Time of Grace

The sacraments are celebrated in the form of a dia-
logue. Think of the dialogues that keep the Mass in
motion. We can also remember the dialogue in mar-
riage between the spouses or that in baptism:—"What
do you ask of the Church of God?," or in reconcilia-
tion—"Bless me Father, for I have sinned," followed
by confession.

This dialogical structure frames the sacraments. At
the sacramental moment, the priest alone intervenes,
saying "I baptize you; I forgive you; this is my body."
This manner of doing things is carefully designated.
Christ, who is the unique source of ecclesial life, inter-
venes precisely in the framework of a covenant be-
tween God and the people. We hear again of the
faithful continuation of the covenant and of the unique
founding moment of the pascal mystery, that of the
kairos—"the night before he died" Each reading of
the gospel is anchored in the phrase "At that time"

Speaking presupposes distance. To make someone
an interlocutor means to set the other apart from that
which is undifferentiated and to come face to face
with the other, to establish verbal contact. The inter-
locutor reminds us of the interdict—that is, of that
rupture which creates distance and which marks out
the respective places of those who differ. This "inter-"
speaks of the Other. Yet distance permits communion

by drawing relation out of the undifferentiated. Speaking face to face (Exod 33:11) to one's child presupposes that the umbilical cord has been cut.

Words demand space. Words demand time for speaking to take place. Remember that one of the liturgical functions of the deacon is to be concerned with the assembly, to welcome them, to bring them together, and to indicate to them where they should be and what positions they ought to take in worship. This welcoming reminds us of listening, of the heartfelt attention which treasures a word and savors its meaning as Mary did (Luke 2:51). But again rumination takes time. That kind of faithful meditation is what binds actions and words together. Liturgy is a harmonization of gestures and words bound up in silence. These three components—gestures, words, and silence—shape liturgical time. Time within liturgy is not only a dramatic action, it is prayer.

The fact that it is prayer makes it possible for us to live the "now" of the covenant in the "today" of our society. Yet two obstacles intervene. We can become completely taken up with the ritual aspect of liturgy in which some people find essentially a mythic dimension. Another opposing obstacle can be described as a journalistic attitude that approaches the events of the day as the stuff of liturgical communication. This gives us on the one hand the indifference of anonymity and on the other empty chatter. Neither is appropriate. Our "today" has the vocation to become a time of grace. How is this done? It comes about through intensity and through depth. Prayer stirs up

desire. The time of prayer awakens a waiting for the Other: "(God) wills that our desire be stirred up by prayer, so that we should become capable of receiving the one who prepares to give himself to us."[4]

A Time for Depth

A word is not true just because it has been pronounced. A lot of people speak a lot and say very little. A word needs time to draw from its depths its most authentic reality. What comes first is superficial. Even a cry does not always express the exact truth. It can hide shadows within itself!

The truth of a word comes from a person giving of himself or herself in speaking. Just bringing up haphazard events in the prayer of the faithful can be a catastrophe, not so much because of painful things described, but because of a lack of involvement. The ritualization of liturgical dialogues is not intended to forbid mention of present realities, but rather to oblige us to go beyond the superficial in order to be open to depth. A word must find its resonance inside the person, and this is not necessarily a spontaneous occurrence. The naive spontaneity of petitions, often emotional, has to go beyond feelings and emotions and touch the heart of the person. The idea of a *sacramentum* conveys the notion of human involvement and therefore of duration. Thus the rites create a temporal dimension.

The time for depth reminds us of the word *dabar* in Hebrew; the word points toward the foundation of realities that have been communicated by divine acts

and words (Exodus, creation). Only in God do word and action coincide. The word is bound up with mystery, with God's plan revealed in the covenant. The fullness of this revelation culminates in Christ: "The mystery of God, that is the Christ" (Col 2:2). Time has been recapitulated in the Easter mystery. Liturgical time is essentially Eucharistic:

"It is astonishing but true: Christ feeds on no other bread than himself . . . The Word feeds upon the Word. The Son lives from himself, for, as the Father has life in himself, he has given to the Son also to live from himself" (John 5:6).[5]

A theology of the two Tables—that of the word and that of the bread—is the foundation for a reflection upon liturgical time, for which the Eucharist constitutes its source and its summit.

A Time of Hope

It is fitting to describe liturgical time also as a time of giving birth. The maternity of the Church is exercised not only in baptism. To be a mother is not only to bring life into the world but also to educate and raise a child. St. Paul speaks of "all together coming to the state of perfect maturity, to the measure even of the fullness of Christ" (Eph 4:13).

This growth is sacramental. It does not model itself on the stages of life—birth, adolescence, adulthood, and old age. The sacraments are forms of life in the Spirit: baptismal rebirth, the gift of perfection in confirmation, and configuration to Christ offered in the

Eucharist. Reconciliation gives hope by affirming, with its pardon, that no one is exclusively identified with their sin.

Hope takes us back to the dynamic nature of liturgical time. Even though Christians have received everything necessary by reason of being baptized in Christ (Rom 6:5), yet Christians are still called to become an icon of Christ (2 Cor 3:18). Become fully what you are!—this is the impulse of the Christian life. St. Paul calls Christians "the saints" (Phil 1:1) but he also invites them to sanctify themselves (2 Cor 7:1). The mystery received is infinite, since God's life is being communicated. Liturgical time is a spiritual journey through which human beings participate in the divine nature (2 Pet 1:4). The fullness of this time consists in a transforming openness to Trinitarian life, to communion with God by an incessant interchange giving energy to our liturgical celebrations.

Conformed to Christ, Christians give birth to Christ in the world: "You are my mother," says Jesus (Mark 3:35). Christians can renew all things by demonstrating that human time is arriving at its fullness. It remains for us to see how liturgical actions manifest this presence. The Church receives itself from Christ; Christ gives the Church a Christological time.

THE LITURGY OF TIME

A pastor leads his people through time. In following what we have said about duration and a favorable moment, we can perceive that the whole Christian

life, in need of time, needs also a wisdom that is the art of taking one's time. Just as liturgical action joins word, gesture, and silence, this Christian wisdom unites *kairos* (the favorable time), the cycle of chronological time, and the love of wisdom (traditionally called *philokalia*—the love of beauty).

Note that the sacramental moment—the time of encounter—that is so much the preoccupation of theologians with respect to the validity of sacramental actions, falls within another reality of a longer duration, that of the liturgical cycle, as we have seen, and also that of the sacramental cycle. In the sacramental cycle, baptism prepares for confirmation, marriage reflects the mystery of the Eucharist, and reconciliation requires the sacrament of Orders. The sacraments are related one to the other. In order to be lived fully, these liturgical cycles stimulate an art of living, a taste for spiritual beauty which, in return, sustains and promotes the desire and the taste for liturgical life. The pastor is principally responsible for the integration of these three dimensions.

Liturgy Takes Time

The question is not just that liturgical celebration takes "its" time; liturgy takes time. It is true that a taste for moving things along, the necessity to finish at a certain time, frames celebrations in a context of schedules. It is better to watch the time in ceremonies rather than to risk seeing the assembly disperse little by little or not come back. Our society will not

accept interminable liturgies or worship without some predictable end point.

But is all this so clear?! Disinterest is not necessarily the result of how long things take. (An interesting sermon of twenty minutes seems less long than a boring sermon of ten). We see people cross the city in order to take part in celebrations which last twice as long as those in their own parish.

Rather than a question of length, it is a question of rhythm. Rhythm is the result of joining two factors together. First, each role must know what has to be done in the proper order: the presider, the choir, the organist, and the assembly. This is the rhythm of the word, held together with silence and meditation. If each one knows what he or she is doing, when to do it, and why it is being done, then the rhythm of the word introduces a give and take between the assembly, the choirs, the readers, and the celebrant which breaks up the monotony, takes time with the rites and makes them feel lightsome. This is the time of dialogue.

Added to the rhythm of the word is that of gestures. An old maxim says the following: "In liturgy the celebrant ought to speak fast and act slowly." During a celebration, in contrast to the laws of physics, one hears more quickly than one sees. Taking time here consists in giving amplitude to gestures, allowing them to reach their truth. A gesture that has to be explained is a dead gesture. Only prayer can serve as a commentary upon a liturgical gesture. Time here serves beauty.

These two rhythms of word and gesture presuppose structure and organization that move toward a summit and then descend. Beauty arises out of this organization. In this way the structure of the Mass rises toward the doxology ("Through Him, with Him and in Him") and descends then toward the dismissal. In a similar way, the liturgical year ascends toward Pentecost and then distributes the Pentecostal gifts. Yes, it is Pentecost that is the summit. The Sunday that follows Easter is called "the second Sunday of Easter," and Easter day is the "first Sunday," just as Sunday is the "first day of the week." Only the feast of Pentecost is unique, without either first or second Sunday. In it, Easter reaches its summit and becomes communicable. The liturgical year also offers us an interpretation of the meaning of weekdays: Wednesday's penitential spirit, Friday's fasting, and Saturday's Marian piety. The liturgical year presides over the seasons through the ember days.

The celebrant presides over the intersection of the two rhythms of word and gestures. This intersection makes Christ contemporary with the assembly: "I baptize you," he says; that is, Christ baptizes (1 Cor 1:13). "This is my body," he says and not, "this is the body of Christ." The celebrant presides, so he must decide if the assembly is losing interest or remaining engaged. It is his responsibility to insert a moment of silence, to speed up or slow down. This kind of attention is a surveillance over time, which serves the assembly. It takes time to enter into prayer. Bunching together words, gestures, and rites, while dropping the

chants of the entrance or the Communion, for example, impedes the reflection of a congregation; people say as much. For the assembly to be recollected means to receive from each gesture, word, or moment a sense of order and identifiable spiritual movement. That is why we need the time to do each thing well. Gestures call for space, for words, and for time. Beauty brings space and time together.

The Times that He Creates

Nevertheless, liturgical life is contained within a Christian wisdom that I have called above a *philokalia*. What is this beauty, except a rapport between what worship does and the rest of life? What would be the point of talking about paying attention to life if liturgical celebration devalued gestures and made gibberish of words? Liturgy is beauty because it dares to make the least action beautiful, whether carrying a chalice, going up to read, purifying a ciborium, standing up, or giving the sign of peace. In making such an action beautiful, it teaches how to ennoble corresponding gestures in ordinary life. Ordinary life receives a vocation to such beauty, if we come to love both life and beauty itself!

This fact however raises a problem for spirituality. Busy people, who don't have time, nonetheless manage to waste time because they don't enter deeply into the things that they do. Often they don't know how to rest, and so they rest badly. They do things half way, and they have a sense of embarrassment and shame or waste time. To be present to what we are doing, this is

the secret of Christian wisdom. It is possible, in doing something even when terribly busy, to have this presence of mind, so long as we believe in what we are doing at the moment when we do it and recognize that it corresponds to God's will and is done in a spirit of divine love. Someone who acts in this fashion feels fulfilled. So authentic use of time is not to act with the obsession of a railroad conductor on a late train, but rather to fill one's time from inside with interiority, even if the pace is swift and the work sustained. This is the time which Christ gives to us. A lack of time forces us to prioritize our business, to decide on what is essential. Time has to be respected.

The real liturgical problem is not whether or not to do away with the chasuble, to reduce the sermon to twelve minutes, or to finish Mass within fifty-five minutes. We don't celebrate like a cook roasting a chicken! The real problem is how to dwell within time so as to make it exist for us as *strong time*. The pastor has to look for a rhythm of celebration and spiritual formation that establishes a good usage of time.

But we too often massacre the time. The altar is already prepared before the offertory; the reader for the first reading goes up to the lectern before the prayer. The obsession about going too long makes everybody more nervous than exact. Yet oddly, at the same time people don't hesitate to go on and on with their testimonials, their prayer of the faithful, their announcements (after Communion), or the kiss of peace. Time is not linked to the personal taste of the celebrant; he

has to be the servant of a liturgical rhythm. Yet sometimes celebrants will throw out details here or there, the sum total of which equals about four and a half minutes, imagining that they have achieved a victory over the pressure to stay on time, without recognizing that in doing so the liturgical rhythm has been broken up. I have presided, feeling powerless, over the complete destruction of the litany of the saints during an ordination. We gained two minutes and lost the attention of the congregation, who were no longer ready to experience the central action of the imposition of hands as a result of this bad performance.

Beauty makes time to be what it is. Liturgical beauty does not require the celebrant to become a film director or an actor. It does ask him, however, to celebrate very much aware of the composition of the assembly and in contact with their sensibilities. There is a close relationship between the composition of the assembly and the nature of liturgical beauty. This rapport is brought about through the active participation of all of those present at a celebration. It is also judged qualitatively; a reading done by a handicapped person might under certain circumstances relate perfectly to a particular gathering. Beauty is not the gathering together of exceptional or extraordinary elements; it derives from the truth of what is being done. A liturgy for a rural parish, without elaborate means, done from the depths of people's heart, can be a marvelously beautiful thing.

Time contributes to beauty, since it is there to allow the contemplation of beauty.

The Quality of Time

We must learn about the quality of time. A pastor is a shepherd of time. Liturgy teaches this *philokalia*— this harmony—because it provides an "experimental time." It allows us to taste the savory moment of encounter; it prepares us for that, it is receptive to that, and it prolongs the encounter in its effects. Liturgy dwells in time.

A pastor has to prepare for such a moment by helping the faithful to be affected by such a time of grace. Their profane moments are not empty; liturgy deciphers the secret fullness of the ordinary. Preparation for liturgy is an exercise in waiting, watching in order to move subtly toward the integration of ordinary experiences of life with the heart of life.

This vigil makes watchers of us—watching for the Other, that One who returns "in the evening, or at midnight, or at cockcrow, or at dawn" (Mark 13:35), and sometimes at the least expected moment. To enter into a liturgy is to enter a ritualized world of encounter. This demands an initiation for the heart; there needs to be a threshold that bridges the passage between the pressure of busy affairs and the recollection of this time of grace which, as the beginning of the gospel says, is always "at that time." "That time" is the time of Christ—yesterday and tomorrow.

"At that time" is the time of remembrance: "Remember and do not break your covenant with us" (Jer 14:21). The memory of the Church, which is the Holy Spirit, reminds us of the inexhaustible depth of the works of God. "Do this in memory of me" makes

present to us an infinite act. Memory opens up possibility for hope. It provides the very roots for hope: "Your name and your renown are the soul's desire" (Isa 26:8). Liturgical time has been grasped by the hands of Christ so as to make human duration within time fruitful.

Coping with the demands of time is an asceticism. The perfectionism of our search for ideals always strives for immediate results. Yet, by its patient repetition, liturgy teaches us the patience of God which flows from God's forbearance. The asceticism of time teaches us to treat each instant as unique. No moment is the copy or the double of another. Time does not resist when Christ draws a moment toward himself. Time's harmony does not waste time or disdain it; rather, it discerns at the core of events the essential quality of the present, given in order to achieve God's will. Liturgy, as a precise moment, symbolizes this asceticism which seeks encounter, waits for meeting, prepares itself, and celebrates union.

THE TRANSPARENCY OF TIME

Extraordinary and Ordinary Time

Liturgy takes place at the crossroads of two different aspects of time. First there is objective, strong time: the moment of celebration. This is extraordinary time within ordinary life. It brings about a great intensity by preparing, organizing, and repeating celebration at the heart of ordinary daily experience. This dimension of time is *subjective* (in the sense that each

person experiences it within their own life story and their own personality). Its intensity is refracted into a variety of different impressions. Extraordinary time is also *objective* in the sense that it invites each Christian to become an agent of graced reality by witnessing in the world to what they have received during the celebration.

On the other hand, liturgy is also an ordinary time within extraordinary life, where newspapers, television, and radio never stop communicating sensational events and stories that are out of the ordinary. Emotion is more common than reflection here; the sensational comes first. So liturgy becomes the anti-surprise, the anti-event. It makes it possible for us to know in advance where we are going. Media events stimulate reactions which are often disproportionate to their true dimensions. Their surface appearance transcends their genuine reality. People become caught up in the energy of the events. Despite all the sensationalism of a media world, worship remains stable. It reveals itself as different from the rhythm of society, where extraordinary things are banal. It signifies another reality—the depth of human history, the concrete reality that lies beneath the surface of things. Liturgy expresses our beginnings in a divine origin and our destiny in terms of our call to unending communion.

The intersection of these two dimensions of time comes to play in the liturgical "birthing" where God is communicated to human beings. Human time becomes progressively marked by this time which liturgy brings

into being. Our activities are all mixed up in the whirl-wind of business; it is possible to do *the things of God* without doing anything at all *for God*. Going to Mass is just one of those things that fit into our schedules. But we don't go there really just out of habit. The point is to go in order to discover God. This act of worship gives meaning to time: it changes its whole spirit.

A Time of Clarity

Liturgy is open to a plurality of different kinds of time. Within liturgy, life in the world and life in Christ come together simultaneously. The annual cycle of worship, the three year cycle of readings, the penetrating meaning of a covenant with God—all these intersect. The individual time of each person becomes integrated with the communal destiny of the People of God.

This plurality of temporal meanings gives a certain breathing space to liturgy. In worship, people find time given to them, a time of grace. They rediscover themselves there. They breathe a new atmosphere, the breath of the Spirit which subtly explains to people why it is they have been brought into creation. Liturgy leads people to rediscover themselves. It leads them back to a fundamental equilibrium.

People need time to rediscover themselves. They need to let go of their busy work and occupations. This "lost" time (in the way that business calculates) is a time of birth. If the pastor organizes the liturgy with a business-like attitude, he places himself out-

side of the project of this spiritual discovery. When youths spend time listening to "pop" music, they take the time to become aware of themselves. Liturgy takes its time, but it encodes within the passage of time the One who knows the human heart better than anyone else.

This discovery of liturgical time leads to a two-fold paradox. By a kind of parenthesis outside time, liturgy leads us through celebration to discover how precious is the time of our life. Celebration has its rhythm and its structures, its own special logic. It also helps us understand that the strong time of God's covenant exists in the very heart of our human occupations. These predictable, full, and intense moments are characterized by the transparency of peace. Profane time loses its opaqueness so that the clarity of Christ who embraces all time shines through. Liturgical time shines its light on our days. Its transparency lights up our darkness. Liturgy becomes translucent both to God and to humans.

"So we can conclude that the reasonable soul has been created to rejoice and to delight with God, and about God and about all things in God."[6]

Far from being out of control, or exhaustingly demanding, time recovers its connection with beauty. The signs of the times symbolize the paschal dawn of the new and eternal covenant.

NOTES

1 *Sources Chrétiennes, No. 36: Homélies Pascales II*, trans. by Pierre Nautin (Paris: Editions du Cerf, 1953) 58.

2 Guerric of Igny, *Liturgical Sermons*, vol. I, trans. by the Monks of Mt. St. Bernard's Abbey (Spencer, Mass.: Cistercian Publications, 1970): "Fourth Sermon for the Nativity," §3, 57-8.

3 *op. cit.*, vol. II: "Second Sermon for the Annunciation," §4, 45.

4 See *Letters of St. Augustine*, trans. by John Leinenweber (Ligouri, Mo.: Triumph Books, 1992): "To Proba, a Widow," 171-2.

5 Guerric of Igny, *op. cit.*, vol. II: "Third Sermon for the Annunciation," §6, 53.

6 Isaac of Stella, *Sermons on the Christian Year*, vol. I, trans. by Hugh McCaffery (Kalamazoo, Mich.: Cistercian Publications, 1979) No. 25, §5, 206.

CHAPTER FOUR

Ecclesial Space

Space is much more difficult to grasp than time. Even before quartz watches, human beings understood the rhythm of time if only through the alternation of day and night and the cycle of seasons. Go to the other side of the world, and you will carry with you some means to situate yourself in time. Time is an interior reality. We all live with a past that we carry as a kind of internal symbol. We live as well with a future for which we prepare ourselves and toward which we propel our energies. It takes special circumstances to bring about the loss of our awareness of time. We have to lose our awareness of the alternation of day and night. A long stay in darkness might bring this about. But time is a strange phenomenon that imposes itself upon our consciousness.

Space remains more exterior. The landscape does not change according to our state of mind. Yet even this fixity of the landscape is tricky because a person loses orientation in space much more easily than in time. Only a slight withdrawal from familiar territory makes us feel disoriented. This word means to lose

one's relation to the Orient—that is, the East. Disorientation is losing our grounding in some fixed point. Yet doesn't it suffice simply to see where the sun rises in order to put a landscape back in perspective? Some known point is needed to allow us to connect again with the feeling of being within a recognizable landscape. Everybody knows that the precise locating of a position requires three points. People go about marking out human territory. We transform inhospitable chaos into "cosmos"—into an organized world. Moreover, the world does not sing to the glory of God until it has been put in order. Nature in all its wildness is frightening. It does not sing, it cries out. The hymn of nature presupposes an order which humans have introduced. Humans impose their space; they mark and claim it.

Out of these rapid observations, let us hold on to this at least: although we can speak about time rather spontaneously, we find that we cannot speak about space without some axis which situates us somewhere. This axis provides a point of departure and forestalls our getting lost. The act of speaking creates a space of communication by providing evidence of a human presence. Hunters know that they have to keep silent if they are going to enter the territory of their prey.

Space then is always marked off. It is defined by the indication of some place, some axis, or some pole. Jerusalem is called "the pole of the world" (Ps 48:3). The world is organized round about the holy city in concentric circles with the temple as the cen-

ter. In Ezekiel 5:5, Jerusalem is called the "navel of the world." Yet the unthinkable paradox is that the Temple, the heart of this center of the world, is (since the capture of Jerusalem in 587) empty of any object. God had made his divine glory reside in the space between the two cherubim that guided the Ark, the Holy of Holies—a point which escapes from being earthly space. It is the place where the inaccessible God lives in the midst of those who belong to God. The pole of the world is a "non-place," a different sort of place which is *present* even as it escapes localization. It both is and is not there. "The Holy One is in their midst" (Hos 11:9). So God is present but set apart. The space between the cherubim is defined as a place of encounter: "There I will meet with you" (Exod 25:22).

TALKING ABOUT SACRED SPACE IS INADEQUATE

This way of indicating space in terms of a presence which overflows space differs from the habitual concept of sacred space. I alluded above to the distinction between chaos and cosmos; between disorder—the *tohu-bohu* of the beginnings (Gen 1:2)—and the order-making work of creation that terminated with God's retiring from the world on the seventh day (Gen 2:2), confiding the world to the human creatures (Gen 1:28). Using such terms, Isaiah puts in God's mouth these words: "I did not say to the offspring of Jacob, 'seek me in chaos'" (Isa 45:19).

Can we find here a distinction between profane space (that is, space not pertaining to the temple) and

sacred space? Put another way, might sacred space represent space emerging out of chaos, coming forth from brutal and primitive powers into a territory of order? Is it some hidden part of human experience within a cultivated and ordered world? Is it somehow the reverse of decoration?

Sacred, Profane, and Axis

These questions are fallacious when posed in dualistic terms. In reality, the question has three terms. Sacred space does not serve only for ceremonies. In Islam, for example, it is considered sufficient for believers to pray in some spot for that place to acquire forever the quality of being a place of prayer. A place becomes sacred by any indication that it has escaped from the sphere of the ordinary; believers have prayed there, a spring has flowed there, a gigantic tree has grown there . . . This quality makes the place unusual and outside the ordinary. It is "outside" the neutral environment. It is a place that is distanced, set apart from homes and from fields. Caves provide a good example of this.

From what source, then, does an "outside place" draw its character? It can arise (the first reason) from the eruption of primitive vital forces; a cave makes us think of the mother's womb, of incubation. Springs and trees possess sexual connotations. Sacred space also makes us think of the human body and its vital movements—warm and nocturnal—that are the sources of life. Sex represents the chaos of the body, at one and the same time disordered and fecund. The

earth is both a mother and an indescribable primitive chaos, both nurturing and dangerous.

The sacred character of a holy place can also arise (second reason) from a space of withdrawal, elevation, or eminence. The mountain where people leave the fruitful plain in order to approach God is a favorite example. Mount Sinai is the place of the encounter where the prophet Elias walked in order to meet God. It is interesting to observe that Israel has lost the exact location of Sinai (Gal 4:25), because it has finally become symbolically united to the Mountain of Sion (Ps 67:17-18).

There are then two types of sacred space, each different, each outside the realm of what we call the ordinary. The first is the place where the forces of life, marked by beneficent and mysterious qualities, emerge; the second is a place of spiritual elevation and adoration. However we should not oppose these two aspects in too rigid a fashion. For example, if the space of chaos includes caves and leafing trees (Deut 12:2) and if the second type includes elevated places and the sun, still the cult of the sun is not without its own secret contact with the forces of life (Ezek 8:16).

Sacred space is not only fascinating and terrifying, following the classic definition of the sacred by Rudolph Otto, it also tends to penetrate the depths of the earth or to lead us toward the heights of the heavens. It possesses its own proper orientation (the third reason). To enter into the depths of a cave does not have the same meaning as to mount the heights of a hilltop. In the one place, persons return toward their

origins, in the other they take off toward their future. The axis which binds birth to the end of life creates sacred space just as much as does the dynamic attraction of our origins and the awesomeness of the heavens.

Delineated Space

From this it follows that sacred space presupposes precise limits. It is a particular cave unlike any other one, a particular mountain (and not the neighboring one) that is filled with awesome power. The space where the burning bush flamed (Exod 30:5) is holy; Moses must take off the artificial covering of his sandals in order to press his bare feet into the sand of this holy space. This sign is interesting: to be barefooted is natural, just as the earth is natural before being touched by human work or the artificial order of gardens. The sacred is more natural in a primitive sense, than are habitual understandings of the natural. It makes us re-experience our origins. Like a womb, the sacred condenses the forces of life. Mount Sinai is carefully set apart (Exod 19:12) and the people may not go beyond the frontier established, just as they may not enter the different courts of the Temple (the Court of the Gentiles, the Court of the Women, of Men, of Priests . . .). To trespass these limits is to run the risk of death.

These observations already suggest an application to churches. The Christian Church is neither a classroom nor a theater. It is a place with its own orientation. Synagogues were oriented toward Jerusalem. The

first Christian churches, even in Palestine, were ori-
ented toward the East—toward the rising sun of the
resurrection: "O *Oriens!*" says one of the Christmas an-
tiphons. This orientation was not only relative to the
altar; the altar's purpose was to lift one's eyes toward
heaven, that is, toward the altar of the Lamb in the
heavenly Jerusalem. It impelled the believer on a jour-
ney to follow Christ, to enter onto a path walking be-
hind him. Sacred space is that of God's nomads. This
itineracy is an important characteristic of those who
seek God, of those who are members of the People of
God.

THE SPACE OF EPIPHANY

A journey takes time. Space mapped out by the ori-
entations described above makes us aware of the need
for the time for history to unfold. At particular mo-
ments of encountering God, precise places are
evoked. To be convinced of this, it is sufficient to re-
member the typical action of Abraham and the patri-
archs. Abraham, Isaac, and Jacob put altars at every
place in which God appeared to them. They set up
these altars in the form of a stele, a dressed stone
such as that of Jacob in Genesis (Gen 28:18).

A Place of Encounter

Abraham made three altars, one at the oak of
Moreh (Gen 12:7-8; Gen 13:4), another at the oak of
Mamre (Gen 13:18) and another on the Mountain of
Isaac's sacrifice (Gen 22:9). Two of these are evocative

of the cult of sacred trees (the oaks), while the third, on the mountain, evokes the sacred heights and is likewise filled with allusions to the sacrifices of the Temple. Is not Mount Sion traditionally confused with the Mountain of God, that of Moriah? In a similar way, Isaac raises an altar next to a well which delineates his landed property (Gen 26:25). In leaving, Jacob prepares a stele (Gen 28:18) and, at his return, an altar in the same spot (Gen 35:17), and finally another at Shechem (Gen 33:20).

These six sacred spaces—steles, altars, dressed stones—are notable for two common points. First, far from reusing sacred spaces already existing, the patriarch chooses a place next to them (Gen 12:8), facing them, at a point where God was revealed to him. It is the place of encounter that is sacred. From this fact, we see that the biblical sense of sacred place is not confused with some anonymous vital force, rather it is personalized. The sacred is in this way transformed; it becomes the expression of a covenant.

An Historical Place

The aspect of personalization leads to a second characteristic. The six places just mentioned are all united by their connection to a promise that is either general ("to your offspring I will give this land," Gen 12:7) or particular ("I will keep you wherever you go" Gen 28:15). Consequently these places are not so much manifestations of some natural sense of the sacred, but rather examples of an historical development. The places become sacred because they become

connected to a journey common to God and God's chosen people.

These two points are important. Notice how Elias hides in a cave at Horeb while God is not present, but then he comes out to meet God (1 Kgs 19:13). Then, secondly, the power of God is revealed in what is the most ordinary reality in the desert, a bush. There the Holy One takes a name that links God to history ("I am the God of your fathers," Exod 3:6). Sacred space becomes the site for a journey on which encounters take place where God takes the initiative to establish a personal and historic covenant. The *space* becomes an *event*, that is, a manifestation of God. We can say that sacred space in a biblical sense is *epiphany-like*.

But we note immediately that this epiphany-like character includes a theology, that is, an explanation about God. This discourse plays itself out on two levels. On one level, it praises the inaccessible face of God. (Moses is not able to stare at the burning bush, and he covers his face [Exod 3:6]; the Temple is empty, spirituality strips the churches of the excessive.) On another level, this discourse indicates the multiple facets of the covenant: the Ark holds the tables of the law, the rod of Aaron and the manna (Deut 10:2; Num 17:10; Heb 4:9). In a parallel way churches, with their sculptures and painted ornaments, give witness to the effect of the covenant in the hearts of believers. These two levels of discourse come together at a common point: the sculptured saint who is artistically represented is not an ordinary man, but a human transfigured from within. The iconography in

space transcribes the "place of the heart." This place is more than *sacred* (in the sense of *set apart*), it is *holy*—it is a place of encounter and conversion.

FROM NECESSARY PLACE
TO INTERIOR SPACE

A church is a holy space. A human heart is also a space for prayer. The transition from a material sense to a symbolic sense takes place in the Bible with disconcerting ease. The episode about Jacob's dream (Gen 28:10-22) is a perfect example. Having stolen from Esau his rights as the elder son, Jacob is forced to flee from the anger of his older brother (Gen 27:43). His mother Rebecca disguises the true reason for the journey of her favorite son as the project of marrying him off not to some stranger living nearby, but to a cousin residing in her land of origin, at Paddan Aram (Gen 28:2). Jacob goes on his way and leaves the region of his father Issac, a land known as Beersheba. He comes to the extreme northern part of the land that is in contact with his father.

The text however hides the name of the place and speaks of it only as "a certain place." Jacob has to camp there for the night. He takes one of the stones from this border space between his father's country which he is leaving and the new territory which will connect him with his maternal ancestors. He leaves his fatherland to enter the unknown. The "place" is liminal territory and a psychological frontier.

With the stone under his head as a pillow for sleeping under the stars, Jacob has a dream. A ladder

connects earth with heaven. To this sleeping patri-
arch, who was powerless, vulnerable, and lacking pro-
tection, God reveals himself and promises to give him
"the land on which you lie" (Gen 28:13). This un-
known place becomes a point of encounter which
transforms the region. God not only promises the
small bit of land where Jacob is sleeping. Just as God
drew Eve out of Adam while he was sleeping on the
earth, so with this man who has left home to seek a
wife, he promises in this place the whole country. The
spot where this promise is made fills the entire area
around it with hope. And this transformation passes
from the head of Jacob through the stone to affect the
land on which his head is lying.

But God who promises to give the land, promises
equally to be with Jacob wherever he goes (Gen
28:15). God dwells within the promise; the place
where God is revealed is the physical person of the
patriarch. Further, by means of the stone, God ex-
tends his promise over the neighboring territory.
Beginning with this encounter, God promises to
watch over Jacob no matter where he goes. Sacred
space is created all around the stone. This holy space
follows the patriarch in his meanderings. Thus we see
two dimensions, *place* and *heart*, as complementary as-
pects of sacred space.

Jacob understood this. "How awesome is this
place!" He did not know that God was dwelling there
(Gen 28:16b-17a). On this stone that he describes with
exaggeration as the "House of God" (17b), he pours
oil and makes an anointed monument, the central

place from which the rest of his life will flow forth. He calls this place Bethel ("the House of God"). We learn that the name of this city was Luz (18), a place famous for its sacred tree. As a place, the city is of no interest. Rather, it becomes important only at the moment of Jacob's dream. (Jesus also was planted in the earth outside the walls [Heb. 13:12].) From this House of God, Jacob moves immediately to an internal experience of God's companioning (20). So there is a relationship between the monument stone—the House of God—and Jacob's own person. He becomes a walking temple witnessing to the faithfulness of God. The house is connected to the heart. God dwells within the "coming and going" between the two. Sacred space moves from material place to personal covenant. Sacred space is a symbol.

When John (1:51) returns to this episode to apply it to Christ, he refuses, as he will always do, to say precisely where Jesus dwells (John 1:38-39). Jesus dwells where the heavens open. To understand this space, you must look at the pierced heart of the Lord (John 19:36). The theme in John of the lifting up of Jesus (John 8:28; 12:32), including the theme of the brazen serpent (John 3:14), symbolized the Lord as the stele of the crucifixion, the anointed of the Spirit, where Jesus unites earth and heaven. Christ dwells within this vivifying covenant. He is the covenant. The sanctified space is the body of Christ. One of the Mass prayers expresses this clearly: "You care for us, Lord Jesus, in offering to us your own body as our dwelling place . . . (may the sick) find within your body their place among us."[1]

Passing from a material location (a stone, an altar, a temple) to a symbolic location (the heart, space, a human body): this is the journey described in the Preface of the Dedication of a Church:

"Out of your goodness toward your people,
you have chosen to dwell in this house of prayer
so that your grace always offered to us will make out
of our very selves a Temple of the Spirit, resplendent
in sanctity; from day to day you sanctify the Spouse of
Christ, the Church of which our hand-made churches
here below are the image. . . ."[2]

The next step is to relate that which is symbolic in the strongest sense (sacramental—"the Body of Christ"), which arises from the mystery of love ("the Temple of Charity"), to the material aspect (churches built of stone).

A SYMBOLIC PLACE

The transition described above from the earthly object to the human heart presupposes, like every symbol, the joining together of three elements: a precise, limited space which circumscribes a locale; a human reality (a body); and finally a relation between the two, that is, an ordering in the active sense of putting things in order. Two pieces of pottery, *tesserae*, brought together form one symbol. All the more so a broken plate. Symbols exist only because of the ordering which, by reuniting the pieces, reattaches them symbolically to a human bargain which guarantees the deposit of a sum of money (or some similar agree-

ment). In every symbol, some moral or spiritual force draws parties together in some order. Without the symbol, they would remain scattered or simply functionally connected.

The Bible is not content only to indicate places where God has been revealed. Since Jacob, the place of revelation is equally an interior space of covenant. In this sense it is appropriate to ask about the nature of divine meetings.

The Temple Not Made by Human Hands

The question we next examine is posed by the story of Stephen who was accused like Christ (in Acts 6:14) of wishing to "destroy this place and . . . change the customs that Moses handed on to us." His answer is astonishing. The Second Book of Chronicles, in recounting the story of the inauguration of the Temple, describes how "the House of the Lord was filled with a cloud, so that the priests could not stand to minister because of the cloud; for the glory of the Lord filled the House of God." And Solomon said, "The Lord has said that he would reside in thick darkness. I have built you an exalted house, a place for you to reside in forever" (5:14–6:12). Such is "the sanctuary, O Lord, that your hands have established" (Exod 15:17). The king was aware that he had built a house where God would dwell, but he knew quite well that God remains beyond earthly space and cannot be enclosed; God dwells in thick darkness. God dwells in two places at once: in one, material, the Temple; in another, heavenly, the darkness.

In his conversation, Stephen responds that "the Most High does not dwell in houses made with human hands" (Acts 7:48). He goes back to a tradition that was opposed to a materialistic idea of the Temple (2 Sam 7:6; Heb 9:24). Solomon is contradicted in the first point. Stephen agrees with him on the second—God's dwelling in darkness. Yet Stephen goes on to cite Isaiah 66:1-2:

"Heaven is my throne, and the earth is my footstool. What kind of house will you build for me, says the Lord, for what is the place of my rest? Did not my hand make all these things?" (Acts 7:49-50).

The interpretation is not immediately clear. We might take it that God dwells in the universe in the sense that God is seated in the heavens (Ps 2:4); in this case the heavens and the darkness are equivalent. But we could also understand, in a questioning way, if having created the universe "by his own hand," God has withdrawn? (Gen 2:2). The universe does not contain God. God is beyond anything created—there is then no need for a temple. All space is profane; it is outside of God's inaccessible holiness.

Given a similar problem, that of knowing whether to worship God in Jerusalem or on Mount Garizim, the Samaritan woman heard Jesus respond to her: "that the hour is coming, and is now here, when the true worshipers will worship the Father in spirit and truth" (John 4:23). The spirit of a human person living

beyond material space corresponds to this God "beyond all known things."

Do we then recommend only a "spiritual worship," making of sacred space uniquely interior space, a place in the heart? Put another way, we can say that the question is this: Does Christianity need sacred places? Putting aside the question of places for assembly where people come together for practical convenience, does Christianity otherwise need particular locales? Doesn't Paul make it seem logical to express personal worship by offering one's body as "a living sacrifice" (Rom 12:1), taking for granted that common prayer uses house churches (Phlm 2)? Thus, just as the Old Testament distanced itself from the pagan high places, the New Testament—maintaining this dynamic—came to completely spiritualize places of prayer: "Where two or three are gathered in my name, there I am in the midst of them" (Matt 18:20). Mutual charity becomes the place of God's presence.

The temple not made by human hands is constructed of "living stones" (1 Pet 2:5). The writings of Paul describe the Church as the Temple of Christ, the Temple of the Spirit (Eph 2:21). What need is there then for buildings made of stone? The Church has its own proper ecclesial space. It is the unique place where those worshipers whom the Father desires gather in spirit and in truth (John 4:24).

Still churches exist as places apart, as places of withdrawal. We cannot ignore them. In so far as they are human constructions, churches become a symbol of God's presence in the world. In building them,

people remember God and make a sign of God for others. Such a building is both memorial and sign.

Such places are designed to facilitate encounter with God. A church is a holy place, not a space responsive to the anarchical forces of nature religion. A church is a place where everything has been designed for respect, adoration, and encounter. It is a place that reaches into the depths of a person, but without dangerous overtones. It is a place of love and of trust. Open (empty) space, the silence—all this helps people to find themselves in contact with God. The church is a space of reverence and thanksgiving, a place of the heart which moves people to reach out for God. In this sense it has some relation to the holy places of the patriarchs.

But this ecclesial space also denies itself in a way. The hope which Christ gave to the Church cannot be contained in any limited geographical spot. The Good News drives us beyond. The holiness of the person of Christ is shared, exteriorized, and communicated—the miracle stories of Christ give us examples of this.

Christianity is a religion without spatial limits. The Church is universal. The strongest image of the Church underlines this: the Church is the Body of Christ dispersed among all nations. So then do we still need buildings of stone? Put another way, does ecclesial space need a place to define it?

If the community represents the place where its own prayer rises toward God from hearts made one, this understanding is based on too "materialistic" and too "extensive" a reading of the resurrection. There is

need for a lucid explanation of the mystery of how people belong to the Risen Christ.

Dwelling in the Body of Christ

The empty tomb—empty like the Holy of Holies—has never been a place for worship properly so called unless, later, because of the building of the Church of the Holy Sepulcher. But its emptiness underlines even more strongly the central role of the cross, planted in the earth. The cross is where the body of Christ, the heavens, and the earth, all came together into one. Going back to Jacob's ladder, the evangelist John (1:51) makes of the cross the new "gateway to heaven" (cf. Gen 29:17).

This theme of a gateway is amplified by St. John. Jesus proclaims that he is a gate (10:7). He is the "narrow gate" (Matt 7:13) because he is the only one to open up the way to the Kingdom. The gate is a unique spot in space.

But even more than being the gate which gives access to a space, Christ also makes the new Temple present. This temple is defined not in terms of Spirit, but of Body: "He was speaking of the temple of his body" (John 2:21).

This new space unites the Body and the Spirit. It is thus a place of relation (we have seen this evoked already), so that Paul defines it thus: "in him the whole fullness of deity dwells bodily" (Col 2:9). Thinking about Christian worship only according to the Spirit and forgetting the body reminds us of an idea in the Second Letter to Timothy (2:18) which reproaches some people for "claiming that the resurrection has

already taken place." On the pretext of spiritualism, such an attitude imagines the spiritual as a kind of immediate, directly grasped, accessible reality. The symbolic is set aside; this is a sort of "materialism." But the absence of the body reifies (makes thing-like) the spirit, because it delivers the spirit completely over to emotional feelings without relation to that which is objective and independent of emotions or moods or subjective reflexes.

But the Spirit "is made flesh": It presides over creation (Gen 1:2), it gives life to the people of the Exodus (Num 11:25), it gives energy to the prophets (1 Sam 10:10), it fecundates the incarnation (Luke 1:35), the Spirit presides over the resurrection (Acts 2:33), Pentecost, and gives life to the Church, the Body of Christ. The Spirit is communicated in a body. The wind that blows wherever it wills (John 3:8) is given by Christ to the assembled disciples (John 20:22). The space delineated by the Spirit has the characteristics of an orienting axis. It points out the Body of Christ. Going back to Paul's expression of "spiritual body" (1 Cor 15:44), we can speak of a "spiritual space" with a three-fold specification of the word's symbolism. Two terms—the body formed by the Church and Christ the Head—are placed in relation to each other to create a dynamic orientation, that of the Spirit of Christ. Out of this comes marriage as a great symbol of the Church (Eph 5:32).

Here we recall how the Body of Christ is the place where charity becomes visible. What is done to the least of Christ's brothers and sisters is done also to

Christ (Matt 25:40); and Paul, describing the attitude of the Church toward the world, tells Christians to practice fraternal love "especially for those of the family of faith" (Gal 6:10). Their way of being Christians with one another is a symbol of their presence before the world. The temple of charity is not built by human hands; rather, coming forth from the Spirit, charity builds the body (1 Cor 8:1). It is made present in a place, in a body, which has the characteristics of this world that is in the process of being transfigured. Christian space is the space where transfiguration takes place.

So there is a dynamic process, since the time of Abraham, in which Christ is the axis. This process describes what we call ecclesial space. This is the space of the Body of Christ enlivened by the charity of the Spirit, placed within history and within the reality of the world as a sign of hope for God's kingdom. The final result of this dynamic movement is that, Christ having handed all things over to the Father, God will be all in all (1 Cor 15:28).

Dwelling in the Body of Christ requires more time and different expressions of the word than what occurs in one locale. As to time, ecclesial space is fundamentally a present moment. It is found between a past that is linked to history and a future that is linked to hope. It is the place where humans are invited to lift themselves up toward God. It is a place that authenticates the deepest meaning of our humanity. But this lifting up comes about because of a decision in the present moment; so encounter is at its roots.

Ecclesial space depends upon the proclamation of the word. The word calls the faithful together and weaves a new bond among them. The place where the presence of God is made manifest is a place of dialogue. The cement of the community owes more to the word that calls Christians together than to the place where they are gathered. The word dwells in the Church.

Place in this sense seeks to bring about the best conditions for realizing a sense of Church that is profoundly aware of the present moment and in contact with God's word. These characteristics show that ecclesial space is more closely related to the community itself than to the building which brings them together.

From this fact, it seems that putting together two realities like "space" and "ecclesial" does not come from a general sense of the symbolic, but from the properly Christian symbolism which is sacramentality. In the end the word "space" loses its relation with any particular localization. It is not a *space* which is able to symbolize or represent the Church. On the contrary, the Church becomes an image; it signifies itself visibly in a place. The Church assumes visible symbols and takes on a bodily expression.

To speak of *ecclesial space,* is a rather poor or artificial expression. If I dared to turn things around, it might be better to speak of a Church which "placed itself in space."

To Construct a Place

This effort to define sacred space leads us now toward some conclusions:

The Spirit builds up the Body of Christ, his Church. This body exists because of God's call; it represents that part of humanity that is sanctified by the sacraments. In its midst, the Eucharist is celebrated and this Eucharist builds up the Church, "a living sacrifice of praise" (Eucharistic Prayer IV). The Eucharistic reality is created from bread and wine offered by believers and consecrated by the word of Christ. In the Eucharist, a new world is given to believers, a paschal humanity is born. Of course, the Eucharist can be celebrated in a house or in the open, for example, during a camping expedition. The space for the celebration is sacred only during the time of the ceremony. After that it returns to its profane aspect. But this way of describing such matters is only partly satisfactory. While such Masses are exceptional, they are not really rare.

It does not satisfy us either to think that Christians have built churches exclusively for the simple convenience of gathering a worshiping assembly. If that were all, they could have done without them—inconveniently it is true! The Eucharist is the sacrament of a new world. Creation has begun to be recapitulated in Christ (Eph 1:10) from the moment of the transforming episode of the cross. The cross is the key to our reading of space. The cross gathers space in its arms to offer it to the Father. No longer is there opposition between a space given over to human hands, measured by human purposes, and sacred space that is set apart.

Space has a vocation to enter into Christ's offering; creation groans with the pains of giving birth to a re-

newed world (Rom 8:22). Creation has been *handed over* to humanity; it has not been *abandoned* to us. While we humans are at work on creation, we are not the measure of what is to come. The destiny of space is larger than our humanity.

According to this interpretation, to build a church is to create a sign within the dynamics of the vocation and destiny to which all space is oriented. Christians do not gather in a social environment, they bring themselves together in a space created for human encounter with God. Building a place of worship witnesses that humans cannot be reduced simply to their industrious, mercantile, or playful actions. It bears witness that this world, including its space, is called to become a body of love, of charity, and thus a world united by friendship. A church building reminds us of the meaning of the world.

Consequently a church building symbolizes the divine vocation of the world. All creation is called to participate in the glory of the Son. It has been made by him and it exists for him (Col 1:16). A church building is a sign which reminds people of the sanctification of the world. This is its cosmic dimension.

This is why, even as the Body of Christ makes the action of the Spirit visible, this Body can be seen in precise places, in churches. There this ecclesial body expresses two complementary realities. It reveals its identity as a particular body called together to express a particular part of earthly reality. And it also brings along with it the world to which it belongs to be renewed within the action of the Eucharist. A church,

implanted within the world, remains mindful of that world. It transfigures it. The Church is consecrated for the world.

Don't imagine that this explanation means that the totality of the earth is transformed into sacred space. Quite the contrary. We remain within the dynamics of symbol: a certain place on this earth becomes related to a new world because of the energy of its consecration to Christ. But just because some property belongs to the Church, that does not make it an ecclesial place. Possessions of the Church, for example, a field, an apartment building where employees live, gardens—these don't become "ecclesial space" because of that. Their use by church people (under one title or another) does not change their nature because of the occupants. Nothing symbolic is engaged here. What defines ecclesial space is not the individual usage which is made of it. The blessing of a private home does not make it a temple. Blessing a house reminds us that God is a refuge and a host (Blessing 487), but the house is used at the discretion of its owners. A church building, however, is the place for a corporate society which belongs outside ordinary time and space. The community receives the Church and passes on the life of the Church. Every Christian, even a stranger, is at home there. It is indeed the "house of the people of God." Under this title, it is a symbol of God's plan for time and space.

TO DWELL WITHIN ECCLESIAL SPACE

It is now possible to tie together the patient analysis that we have done and to come to a more complete conclusion. I will call your attention to five points.

Space as the Sign of a World Made New

A gathering can come together in the open air. In addition to the temple (*naos*), the ancient Greeks used another gathering spot open to the winds with no other demarcation than a fence (the *temenos*). Christian liturgies may be celebrated in a field or a clearing. The place is already sacred: a place of pilgrimage, an enclosure around a shrine . . . or it becomes sacral on the occasions when a Mass or prayers are said there.

In these cases, the meaning of the place depends directly on the assembly which gathers there. The place is made for the assembly and the assembly gives it its meaning. The assembly occupies the place, in the sense of taking it over. The place contains the community and allows it to express itself (note the density in the front of such a crowd and how it unravels in back as it strays off into the surrounding countryside). In such a gathering the meaning of the space is diluted as it spills over the borders of the spot.

A church, which is a constructed ecclesial space, (while better protected) also plays this role. Here again there is a "coming and going" between the container (the edifice) and the contained (the assembly). But note two differences here: a space in the open air

only achieves full significance when a crowd fills it up; whereas, on the contrary, a church can be populated by ten persons at a morning Mass. The church condenses presence. Further, a church building is not only the simple reflection of an assembly. It signifies the place where the ecclesial body exists within creation. It relates the community to its neighborhood. Although set apart, the church building is a dwelling in the midst of other dwellings.

The church as space offers everyone in the world a place. Romanesque sculptures show us a world of imagination that erupts out of human desire, strange as it is. Gothic stained glass windows lift up toward the light even those who may live in a hovel. The church building makes hope visible on earth. Its construction requires it to cut through the ordinary. It does not reflect the qualities of day to day, rather it reveals the depth and the aspirations of human living. This is why we betray the meaning of a church when we design it like a theater or a classroom or a multipurpose room.

There certainly are financial and technical demands that must be faced! However ecclesial space, more than being a mirror for the ordinary, expresses the vocation to transform the ordinary. It is *other*. In a world of concrete, there must be churches made of wood! The space of a church witnesses to "Church." It says more than what the statistics of the community might indicate. To build a church, art is needed—that is, the awareness that humanity is not reducible to human roles, utility, or social rank.

This is what the idea of a church allows us to see. In different ways during different periods, the church building indicates the human vocation to authentic life in diverse circumstances. The church both reveals and hides. Our contemporary period that wants to see to the bottom of everything, perhaps really sees only the surface of things. In renouncing high columns and shadowy corners, we make it impossible to be hidden; but sometimes to be hidden is the only way to secretly see. There is no depth of vision without a slow and painful unveiling.

The Community as Space

In Isaiah 5, the vine of God, the beloved field, is God's people. Ecclesial space is designed for a community always bigger than the present gathering, since all nations are invited to take part. This shows the importance of the porch, which is a symbol of Christ.

The heart of the community is evidently found at the place of the Eucharistic table since "the Eucharist makes the Church." Ecclesial space derives its meaning from the concentric circles that move out from the Eucharistic table. The activities of the community derive their power from there and later return there to be lifted up to their apex. As the place of Word and Sacrament, the Church allows the Body to be seen.

In addition the church is an "available" place. It is useful outside the times of liturgical rites. For centuries, it was open to use for activities which today we would call profane. From the end of the Middle Ages, when the clergy became increasingly cut off from the

profane culture, sacred space required more and more respect and silence. The Counter-Reform accentuated this tendency. Yet it is still true that, in addition to its ritual purposes, a church building is a place of prayer, a free space where people can enter even for rest. A church is a space *offered up*, like the Eucharist.

In addition, the church is an historical place: it bears the imprint of generations that passed through for prayer. It bears the evidences of those who were buried there and sometimes who fought and died there. A place faithful to memories, it carries traces of a community through changing times. But this is a living history. Our ancestors had a freedom to adapt that our present archaeological determination has lost. In the past each age adapted the space according to its own vision. To desire today to reestablish objectively the way things were yesterday is evidently to be fixated within our present conception of history. Such an "objectivity" creates mausoleums. History is recorded only in order to be re-read, re-appropriated, and so re-created. For church buildings, we need artists who are true interpreters. This task requires not technicians, but people who really have something to say.

Finally, ecclesial space is not limited to the church building alone. It includes a grouping of four types of elements: teaching (the school), healing (the hospital), praying (the chapter room), and governing (the chancery). We should add the cemetery (the place of the relics of the local saints). This comprehensive ideal was rarely achieved and even more rarely pre-

served. However this ideal expressed the idea that all these ecclesial responsibilities were rooted in the Eucharist. The service of the community and of its body is ministerial; the ministries flow from the Table of the Lord. No bureaucratic reality can express all that. Ecclesial space as community requires mindfulness of the center of the community—the offering of the Lord.

Space as a Journey

To enter a church building is to allow oneself to be addressed by the One who lives there. We do not know immediately what that One is going to say. The church is a space for stripping down: our liturgy begins by begging mercy. This is what sets our prayer in motion.

However, this does not mean that the space has no clear orientation. The architecture of the space possesses a definite order and meaning. The church is turned toward the East to indicate the eternal arising of the resurrection. Even when this axis is not always respected, the altar presides over the space and draws our attention. The arrangement of seats, pulpits, lights, the sanctuary, the lectern—all this converges on the altar.

The altar is not, however, the ultimate point of reference. The altar calls to mind the heavenly Jerusalem. There is something beyond the altar, whether above or behind. The altar draws our attention precisely in order to suggest what is invisible. Ancient church buildings placed mosaics or frescoes behind the altar in order to represent those "realties beyond."

To walk inside a church—in processions, in the Way of the Cross—reminds us of the journey experience of the Christian. Such walking brings us into intimacy. Silent prayer gives us the desire to lift ourselves up. The material space opens upon interior space.

Space—Emptiness and Presence

For a pragmatist, a church building represents a lot of lost space in its height and in the open area around the altar. This amplitude is not just for the sake of allowing liturgical movement, however. The emptiness goes beyond what is truly necessary for a setting of a scene or a stage. This emptiness is emphatic in its superabundance. This constitutes one of the big differences between ecclesial space and a meeting room. A church is spacious at the entrance, open at the sides, open around the altar, open above—this openness is for silence and for sound. It is for a silence that is intentional, for a sound that reverberates upon itself. "A voice in the desert."

The church building is both an epiphany-like and a utilitarian place. The church has no greater utility than that of making possible the epiphany of the Christian mystery. This vision largely forecloses technical questions of visibility, comfort, or practical use. A church is not polyvalent but polyphonic.

Such freedom of empty space underlines the very particular type of presence that is God's presence. God is both present and absent. God is really present in the reserved sacrament, but impalpable—the sacramental presence of the One who sits at the right hand

of the Father. The emptiness of the building reminds us of an immaterial fullness; the absence bears witness to a superessential presence. This description is preoccupied not only with the multiple details that prove a church to be useful. Even when not in use, a church speaks of its meaning by its symbolic value. Even when it has been put to use as a barn, it remains a "church" precisely by the disproportion between what it is and what it is being used for.

In this great emptiness, the architectural axis exerts its power. In this context, each object, statue, chair or, lectern finds its place. Even when actually used for a secular function, it still reminds us of the "beyond" signified by its space and its volume. A church is never full. This is why it is a bit useless to want either to totally strip a church or to ornament it abundantly. The question is not there. The real question has to do with the fundamental architectural order of the building. The world signified by sculptures, murals, or paintings has as its point to remind the community how it is invited into the same transfiguration as those whose images they contemplate.

The statuary and the frescoes all obey a logic—the logic of faith. The distance (the emptiness) which divides the assembly from these images describes a space for conversion. To walk across the church and go to kiss an icon is a journey that signifies that persons can still change, that persons possess the space of moral freedom.

We are then in a space that is fully symbolic. A "saint" cries out to a believer that he or she can begin

to live in the power of the Spirit's breath. And then ecclesial space takes on its fullest meaning as it escapes from two dangers: (a) it is not reducible to its material function or to its social usage, (b) but neither is it an allegorical bazaar stuffed so full of images that each element is in competition with others. Ecclesial space becomes symbolic because of the order that reigns there. The openness calls us back to the presence and to the need for openness.

So it is possible to think of the Church represented as a microcosm. The images of the zodiac and of the work of the fields situate ecclesial space in the universe and in time. But the universe is divine space only because this "openness" exists. The universe is a temple because God is distinct from it in creating it. This same interplay between emptiness and presence bestows upon a church building its universal significance.

The Epiphany-like Space of Christ

Eucharistic space widens the heart of the believer, "the Temple of the Spirit" (1 Cor 6:19). Encountering God gives believers new horizons. Ecclesial space is a place for rebirth. In this Eucharistic place where the Church bespeaks its presence in the world, we find our vocation. This place receives us and teaches us to live. Ecclesial space reveals the covenant. It manifests God as "the friend of believers" and believers as living according to the heart of God. A church is essentially a Christological space, because Christ is the unique mediator between God and humans (1 Tim 2:5). This space is consecrated for the sake of remaining bound

to Christ and living for him in the time between his ascension and his return. It is the place of an epiphany.

In the church, the baptized, consecrated by an anointing, dwell in the Body of Christ:

"We joyfully dedicate to You,
infinitely great God,
this house of prayer which human persons
have built.
It is a symbol of the true and eternal Temple
and the sign of the heavenly Jerusalem.
For the Temple that you have consecrated
for yourself
where dwells the fullness of divinity,
is the body of your Son, born of the blessed Virgin."

(Preface of the Dedication)

NOTES

1 Prayer after Communion, Mass for the Sick (from the French Sacramentary).

2 Common of the Dedication of a Church [outside a consecrated church], (from the French Sacramentary).

CHAPTER FIVE

Dance and Faith

All theology takes place within a cultural context. First Peter (1 Pet 3:15) tells us that theology has as its goal to "give an account of the hope that is in us" and this accounting can only be done in terms of the diverse cultures of humanity and their typical characteristics. When the Bible speaks of dance, whether referring to the miraculous crossing of the Red Sea (Exod 15:20) or to the return of the Ark of the Covenant to the city of David (2 Sam 6:14), we are aware that we are dealing with a phenomenon consonant with the culture of those times and that people. Sacred dances are as ancient as the human race. However, our own culture does not consider dance to be immediately related to the sacred. The role of a dancer is different.

Sacred dance is not, first and foremost, the focus of my attention here; rather dance as an art in itself is the larger theme I want to treat. However, if sacred dance is no longer a spontaneous expression in the contemporary world, still we have to recognize that the Bible uses dance to evoke the joy of God in such a

phrase as this: "God will dance for you with cries of joy" (Zeph 3:17).

If the Bible speaks not only of sacred dance but also of dances that we could call profane (for example, Salomé's dance before Herod in Matt 14:6), the very fact that the Bible connects dance with God forces us to transcend cultural attitudes and to wonder about the meaning of a title given to God when we use the phrase "The Lord of the dance." God raises a surprising question for us that provides us with material for a theological meditation. What is the relation between God and dance? That is the focus of the present investigation.

Everyone is aware of the difficulties which alienate dancers from the Church. It is an old story told many different ways that has left people thinking about dance as a suspect phenomenon. Dancers and actors have been shadowed by the same suspicion. Odd, isn't it?, when we recognize that God has all the qualities of a dramatic artist—why then has dance been so long connected with a halo of suspicion?

We can immediately note a difference between actors and dancers. The actor performs through the mediation of a text, a plot, and a stage setting. On the other hand, a dancer is able to perform with nothing other than his or her own body. Dancers are their own text, their own music, their own rhythm and composition. Dance directly raises the problem of the human body. It exposes the body. Social change can either heighten or diminish the importance of this fact, but it cannot change the nature of dance. Dance

involves a relation to the human body, either individually or in a group, which necessarily intersects with the sensibilities of an age. It touches upon how humanity understands itself at its deepest level. The words of a Bach chorale, "God sets the world dancing," suggest that the whole of creation, humanity included, has emerged out of a divine dance. This image begs for further explanation.

The insight has to be disengaged from a long and painful history that I will try to unravel in order to arrive at a better understanding of what it means. It is a history marked by misunderstanding, alienation, and mysterious truths which have been buried by neglect.

EXCLUSION AND CULTURAL MEANING

Is there some fuller meaning to the Church's exclusion of dance through the ages that suggests deep and positive concern? This may seem like a contradictory question! How might exclusion suggest a positive concern? It is likely that something of this sort took place, to the detriment of artists in the world of dance. Three examples will illustrate what I mean.

St. John Chrysostom

We often say that the Church's opposition to dance came from the moral decline of dance during late Roman antiquity. The Romans would have been more crude while the Greeks were more refined. Unfortunately this observation extends to every aspect of the Mediterranean world in late antiquity. Was not Byzantium called "the Second Rome"? Among

many other examples, let me mention one, that of St. John Chrysostom.

Between 386 and 398 at Antioch, St. John gave a series of six homilies which have been grouped under the title *Homilies on Azariah*. In the fourth of these, given in 386, he criticizes the people who go to theater as follows:

"Don't you see how people sitting in the theater sweat as their uncovered heads bake under the rays of the sun, all to become captivated by death, to become the slaves of a prostitute?" (4,3).[1]

On the theme of theatrical spectacles in his first homily of the year 395, he addresses the problems of liturgical assemblies this way:

"There are in the church assembly persons who, scorning God and having the idea that the inspiration of the Holy Spirit is commonplace, cry out with loud confusion and put themselves in a state close to madness, because they whirl about, twisting their body and manifesting a behavior foreign to spiritual tranquillity. How sad and unfortunate!" (1,2).[2]

He goes on to explain:

". . . look at yourself acting as though you were a mime or a dancer with gesticulating arms, stamping feet, and your whole body in dislocation."

Finally he concludes by denouncing the fusion of theatrical and ritual elements:

"You are confusing in every possible way the behavior of theatrical spectacles with the ritual of the Church."

Coming back to this subject at the end of his preaching, Chrysostom condemns this confusion:

"We are not prohibiting liturgical acclamations, but only confusing outcries; we are not prohibiting the speaking of praise, but speaking in disorder, mutual rivalries, arms waving in the air pointlessly, stampedes, unworthy behavior, the entertainment of people who waste their time at the theater or the hippodrome . . . There is nothing that predisposes people to scorn the oracles of God like the excitement which is found in theatrical spectacles" (1,3).[3]

For the moment, let us recall the "indecency" condemned by the preacher under two forms: excitation close to that of a trance and a lovesick lassitude. Both of these attitudes may be problematic in themselves, but become unacceptable for Christians, especially in Church. The preacher of Antioch summarizes the attitude of the churches of his period: they reject the assimilation of secular theatrics into the liturgical assembly.

The Medieval Councils

Since the publication in 1914 in the *Revue d'histoire ecclésiastique* of two articles by Dom Gougaud, the decisions of many medieval councils have become well known. These acts of the medieval church have a common tendency to exclude dance completely from Church. Only a few rare examples remained: ten chil-

dren dancing at the Cathedral of Seville for the feast of the Immaculate Conception, the dance-procession at Echternach in Luxembourg for the celebration of St. Willibrord, and a few others.

But we should look at the texts more closely. In the Gougaud collection, the conciliar acts extend from the Third Council of Toledo in 589 to the *acta* of the Archdiocese of Cologne in 1617. A proverb of St. Augustine, that *it is better to work than to dance*, was clearly an important authority for all their complaints against the dance that fall under three principal headings.

First, dance is only a game which is worthy of derision (Basel, 1435; Narbonne, 1551). The Council of Narbonne even uses the ancient word *tripudium* (c. 47) to designate leaps and dances executed for soothsaying.

Dance is thus understood as an irreligious habit (Toledo, 589) or as "secular mannerisms" (Auxerre, 573/603; Estinnes, 743). Thus they are "troublesome" (Cognac, 1260). In 1617 the Archbishop of Cologne qualifies dance as dishonest and contrary to the dignity of the Church.

But above all—and here is the most frequent and vehement reproach against dance—it is a shameful thing, *turpia*, that is vile (Toledo, 589; Chalon-sur-Saône, 639/654; the Acts of Pirmin, c 758; Rome, 826), obscene (Chalon and Avignon, 1209), luxurious (Pirmin); in a word, "diabolical" (the Homilies of Leo IV, 874-855).

What should we conclude from all this? This at least—there is an oversimplification about the nature of dance. These texts are opposed to the vulgarity of

farcical or crude dances in sacred places. It is therefore the noisy and crude rusticity that is being condemned. Without having to cite words from the acts, we can claim that the dance as an art form—with all that that connotes about authenticity, commitment, and hard work—would condemn as vehemently as the Church the deformities in question. We cannot however forget one important aspect, namely, that these condemnations of excesses, while justifiable, have brought about a general low regard for every form of popular dance in so far it represents naive self-expression, even if it might represent genuine religious spirit.

This oversimplification, doubtlessly brought about because of the vulgarity and the crudeness of past times, had as its goal to bar from the church disturbances which might arouse in people their less noble inclinations. But, let's face it, this has done damage by opening the door to those who would have us believe that every form of dance is reprehensible.

Jansenistic Rigor

The Jesuit colleges used to have ballet and dance masters. The Jansenist reaction went so far as to condemn dance; Pascal classed dance in the category of *distractions*. This attitude of Pascal is an example of the rigorous moral attitude that would last a long time. Pensée 274 describes the general principle: "Without examining all the different occupations in detail, it suffices to include them all under the heading of distractions."[4]

A *distraction* is anything which leads a person away from reflection on the end of life, the humility of the human condition, and the seriousness of one's earthly state. By comparison with such serious questions about existence and vocation, everything else is only futility, with which miserable human beings will either go astray or become lost:

"The only thing that consoles us for our misery is distraction, and yet it is the greatest of our miseries. But distractions amuse us and bring us imperceptibly to death." (128)

Whereas classical morality above all warned against the fires of sensuality and the excesses of human affection, Pascal examines not only these superficial struggles, but also the existential drama which snatches persons out of themselves. Wanting to give examples of this flight into superficiality, he writes:

"They [humans] possess a hidden instinct which impels them to seek amusement or occupation outside themselves and comes from the consciousness of their perpetual unhappiness" (269).

So dancing is considered to be at the service of this distraction. It can provide only the illusion of life. It becomes a mask to help us forget that "the heart of a human is hollow and full of vileness" (272). Turning their back on the truth which might set them free, people amuse themselves; distractions are flight from life and a mockery.

"Vanity is the pleasure of leading others to the superficial. Dancing: we have to think carefully where we are going to put our feet" (269).

"Would it not spoil [people's] pleasure to concentrate on keeping time to a tune, or the skillful placing of a ball, instead of enjoying the peaceful contemplation of the splendor and majesty that surround [them]?" (270).

The Jansenists were serious folks. Pascal's attitudes of condemnation were theirs as well. Without following them in their lapse from orthodoxy, most Catholics nonetheless shared their rigorous suspicion of pleasure. One example, that of the Curé of Ars, will suffice:

"We can believe that the devil roams around the earth to light fires of impurity in the heart of Christians, and that he provokes them with even more fury through the means of balls and dances." (Sermons)

The Curé of Ars adopted the negativity of classical morality that moral theologians had already softened with the concept of "wholesome dances." Pascal's critique is situated elsewhere: dance belongs to those distractions with which people try to forget themselves. It presupposes as resolved in the negative the question: *What if God has invited us to dance?*

Between Saul and Salomé
In 1712, during a controversy about sacred dance in churches, Jean Bouhier, president of the Parliament of Burgundy, complained: "These are abuses that the

decadence of recent centuries has introduced into the Church and which are strongly alien to the kind of modesty that was recommended by the first Christians."

Modesty: the word has been uttered. Above all, modesty means keeping a moderate control. The wholesome middle where virtue is found can be lost in either of two directions, either by falling into trances or by giving way to lust.

The Bible mistrusts stimuli which provoke a condition where people lose self-mastery. A trance is immoderate. It places a person under the control of unconscious, anarchical forces, making one the victim of one's drives. Hallucinogenic drugs, drunkenness, and religious contortions are all condemned together. The priests of Baal danced and whipped themselves to the point of shedding blood and uttering prophecies (1 Kgs 18:26-28). In primitive times, such measures were sometimes interpreted as signs of a person's possession by the Spirit of God. This is how we must understand the condition of King Saul: "A band of prophets met him; and the spirit of God possessed him, and he fell into a prophetic frenzy along with them" (1 Sam 10:10-11).

Verse 13 speaks of Saul's "frenzy." Commentators hesitate to interpret his condition, some assigning it to God's good pleasure in giving the Spirit, others interpreting it as retribution indicating the future decline of this king. In any case, it is certain that later, at the time of the prophet Zachariah, this type of prophecy, with its exhibitionism and violence, had been completely rejected and lost favor (Zach 13:6).

Violence is opposed to modesty. Lewd dancing is violent and immodest, but in a way different from what we see in Saul. Look at the figure of the daughter of Herodias, later known as Salomé. "When the daughter of Herodias came in and danced, she pleased Herod and his guests" (Mark 6:22). The result was that the king, seduced, consented to the decapitation of John the Baptist.

Between Saul and Salomé we must note a difference. The difference has to do with who it is who becomes affected by the violence set loose by the dance. In one case, it is the dancer who is affected and falls into a trance. In the other, it is the watching public that is captivated and driven beside themselves—such was the effect of Salomé. Dance is dangerous because it can set lose a violence, an immodesty, that no one can further control. The body appears in dance as yielding to its drives, both violent and the object of violence, both seducing and seduced. War and violence both get mixed up in the ecstatic dances of warriors. Dance has the ability to push people beyond the limits of their mastery of themselves and their emotions.

This observation explains the reason for the constant condemnation of popular dancing in the Church. Caught between violence and concupiscence, the innocence of dancing has never been taken for granted. In 1924, the very serious *Dictionnaire de théologie catholique* (DTC), despite making efforts at reflection and objectivity, still wrote the following: "country dances should be considered generally very dangerous

. . . in Christian parishes where dance is not custom-
ary, the confessor ought to take every possible means
to prevent their introduction" (Col 129-130).

Games, Manners, and Work

This absolute rejection of dancing (except for folk
dancing) can be illustrated by a saying of the Curé of
Ars in the sermon noted above. A fictional parishioner
replied to him: "What would be wrong with taking
some time for recreation?" The Curé responded: "Stay
with me for a moment longer, and you will see that
there is not a single divine commandment that dance
will not lead you to break, nor any sacrament that
would not be profaned by your dancing."

Nonetheless, St. Thomas Aquinas himself admitted
the need, indeed the necessity of play in order to
relax too serious an attitude: "playful deeds, which
are meant to please, not to hurt . . . are free from
sin and offer some mitigation."[5]

The playful quality of dance, as the DTC notes citing
St. Thomas, means that dance is not forbidden as such. It
is good or bad according to the intention of the one
who does it. It is even good if it is done for the sake of
relaxation (Col 111). The DTC examines costumes and
gestures used in dance. Discussing "society balls in aris-
tocratic salons," it finds a certain fittingness with social
customs, a social force which tempers immodesty (Col
113-114). If playfulness or social fittingness is able to hold
dance within modest limits, T. Ortolan, the author of
the article "Dance" (Col 121), remarks in passing about a
new factor which suddenly amplifies our perspective:

"Dance as practiced in our time is an art that one must learn if one wishes to possess its artistic quality; a person can only excel in it through artistic development, just as in music or painting . . . in our day, this art has become so complicated that it demands frequent practice for success."

Ortolan then mentions the hard work involved and reasons as follows:

"the attitudes and movements, inspired by choreographic art, can only be executed by dancers who are professionals" (Col 122).

This brief historical sketch suggests a few preliminary conclusions. Both the biblical and ecclesiastical traditions sought to protect men and women against themselves. The human heart can be immodest, easily losing its self-control. The risk is greater when there is no instrumental mediation: neither piano or harp as in music, neither brush or pigment as in painting. The living body is both the point where intemperance may be experienced as well as the place for work to express creation. The whole history of the exclusion of the dance, together with all the apprehensions that go with it, make it clear that this line of thinking was conceived as a protection.

Paradoxically, however, the result has been that in hoping to protect people from their uncontrollable appetites, this tradition left the way open for the discovery of an art form. Dance as art is by no means spontaneous: it is a production, an artifact resulting from hard work. Nothing is further from the sponta-

neous work of nature than that sense of the *natural* that emerges from long and even painful exercise and which is the result of mastery and willing practice.

To return to Pascal, we might critique dance as a deformation of life's serious meaning and a decision to abandon oneself to forgetfulness; dance then hands stewardship of the self over to nervous impressions. This forgetfulness creates vulnerability to uncontrollable drives. It leads beyond moderation. This attitude does not mean to condemn playfulness as relaxation (the defense given by Thomas Aquinas), but it disapproves of dance in the sense of "distraction," that is to say, allowing freedom to be carried away by futility. In this sense the act can be harmful.

But this perspective allows for the creation of an art form that has its own rules, its rhythm of work, and its goal of transforming the random desires of a body into a carefully molded human expression. St. Thomas's intuition is helpful here; he puts dance not in the context of some isolated action, but under the banner of an intention. To claim that "dancing is not a sin" does not help much, even if it might please us. One might as well say "to drink is not a sin"! Everything depends on the moral intention. Dance, like every art, has to be placed inside a structure, a movement toward some end. This is where the quote from the prophet Zephaniah (3:17) cited above will prove to be particularly illuminating.

THE LORD OF THE DANCE

To condemn a ball is not to condemn a ballet. Between the two there stands the mastery that makes great art. If we disentangle the lumping together of all the various forms of bodily movement condemned through the ages, we find an opening for a possible understanding and collaboration between the Church and choreography.

Art as Humanization

In the creation story, the Bible describes the coming to be of all things as a separation—separating heaven from earth and the waters from the dry ground. When it comes to the human, the Bible affirms a two-fold transition—the human creature is created in the image of God, at once bound up with God and different from God. The human creature is not God, but still united by a resemblance to God (Gen 1:27a). Already we find the hint of a covenant. Further, no single person is the whole of humanity; a person is either man or woman (Gen 1:27b). The second creation narrative tells us how Adam was obliged to name and classify all the creatures so as not to confuse this world of objects one with another. He speaks and by doing so makes distinctions (Gen 2:19). But the first human does not arrive at the full status of freedom until he receives the gift of his partner, his *vis-à-vis* who is matched to him as both *like* and *other* (Gen 2:20-23).

While present to the world through his body (earthly, drawn forth from the earth), the human

person is invited to keep a certain distance, so as not to fall back into the earth, and to respect the gap between himself and the world from which he arose. Two dangers lie in waiting for us. The first is the danger of falling back into the world because too many bonds hold us in contact with it. So we risk identifying with the earthly. All the statements concerning dance that worry about its negative dynamics are touched here: becoming one with nature, abandoning ourselves to the river of life, total expression of the self This kind of vocabulary suggests a particular time and world, that of prenatal existence, of the mother's warm and encircling womb. An old memory of fusion haunts our dreams: "Can one enter a second time into the mother's womb and be born?" (John 3:4) asks Nicodemus in the middle of the night.

To abandon the body in order to go back to these maternal waters where there is a confusion of objects and beings, is to renounce the gap through which freedom comes into being. Art is a snatching, a rupture, a going beyond: it forces a body to say what it would not spontaneously be inclined to say—to transcend its native abilities. Art is the opposite of naiveté. It is second nature—a second birth. The suppleness of a body is something more than acquiescence. Because it is willed, chosen, and learned, artistic beauty has more meaning than an acquiescence that can shift with any wind. The fluidity of a disciplined body says more than flowing water. While it speaks conscious truth, it touches unconscious sources. Art reveals humanity to

humans. This is how human persons enter into the full significance of their humanity.

A second and different danger is this, the body forgets its connection to creation. To deny the world or reject the body boils down to using the body to achieve isolation. This contradiction is one of the traps of idealism, which is one of the dangers of academicism. Idealism makes an idol of itself. It can only reproduce images of its self-fascination, not truly create. It may use marble, canvas, or the body; but without entering into a proper respect for any of them. This is why idealism is so close to decadence and to luxury.

Between these two temptations, confusion on the one hand and isolation on the other, true art is guided by a logic of synthesis. There really is a truth, partial but real, about marble, about pigments, or about the body. It is essential to take account of this truth—and the consequences are bad when we forget. For true art is connected to this truth. But this objective truth must become linked to another truth, another movement, another intention—that of translating interior experience.

Art is true when it promotes unity: the artist has to marry the marble in order to discover the beauty of a statue. The dancer must espouse the body before it will be able to articulate the inner desire that moves it, the beauty that it seeks to express, and the meaning for which it searches. Art knows both engagement and renunciation, approaching and backing away. Its truth is like a nuptial relationship. Art depends on another than itself—the project, the intention, the meaning—to

draw out of marble or the body a new truth and a greater reality. Art delivers the person to his or her humanity. It makes the person *be*. "Glorify God in your body" (1 Cor 6:20), because the body is a cathedral, the intimate chamber where the Holy Spirit dwells (1 Cor 3:17). Art makes distinctions precisely in order to be able to bring elements together.

Transfiguration as Art

We are not easily inclined to call art a transfiguration. Why not? Art evidently represents an important transformation of the human person. The work we do to eat, to pay our rent, to buy our clothes is a necessity; it may differ in different cultures, but it is necessary. Such work indicates the finiteness of the human; we are obliged to provide for our health and well-being. The word *work* keeps some of the sense of its Latin origin *tripaliare*: to make us suffer.

Culture and the arts are structures that allow us to break out of the constraints of simple necessity. Humanity is a product of culture. But culture creates humanity according to the dreams of living persons.

The whole question of human meaning depends upon knowing who shapes the aspirations of the human heart and what spirit fills human imagination and its desires. This question requires the ability to distinguish between "products" and "creations." By "products," I mean things that people make, the result of our industrious activity. We produce as many objects as we have ideas, whether automobiles or books. But we must remember that these products are neces-

sarily less meaningful than persons, since it is persons who have fashioned them. The person is the measure. Sadly, we can lose ourselves in the products of our labor. We can make our body an object among other objects, a simple reflection of ourselves. We can become absorbed in ourselves. The product is a snapshot of the human spirit. If we get caught inside our inventions, we become like what we have made. We create prisons—perhaps gilded ones—but prisons all the same.

Creativity begins with a product or a work. But creativity deals with products which do not become absorbed in themselves, which don't exhaust themselves and remain open to multiple transformations of meaning. Creativity comes about through the movement of a wind which "blows where it will. You hear its sound, but you do not know where it comes from nor where it is going" (John 3:8). Creativity remains open to all sorts of possibilities. It shows us that the human person is greater than mere humanity. It is not simply concerned with a transformation of the person who is the stimulus and the goal of action, for this would once again be narcissistic self-absorption. Creativity is a transcendence toward unknown and infinite space: "God gives the Spirit without measure" (John 3:34).

Some sort of transfiguration then is at the heart of true art. It snatches persons beyond their limits to lead them out of everyday necessities and into what is truly necessary for a full and free humanity. This is grace. This transfiguration distances itself from the earth to welcome a promised land. Creativity is a pact, a covenant.

A Covenant in a Body

Dance offers the best example of this kind of transfiguration. Musicians must use a piano or some other instrument, painters must use their canvas. The dancer is alone with his or her body. Like a music without sound, like a drama without a stage set, the human gesture occupies space with a rhythm that leads to rest. Is not this rest, this peace, what draws into one all the gestures, leaps, and movements that dance uses to express itself? Many gestures are used in the effort to reach beyond gesture. The body joins itself to all these rhythms in order to bring them into the fullness of silence. It seeks the elusive moment of beauty which expresses a reality beyond our power. Dance does not leave any markings behind. Whether one person or a company of dancers, dance creates in the body an expression which is bodily ecstasy, spiritual excitement, tension, and welcome. The dance expresses, to use the words of a Greek mystic, "the incorporeal within the body."[6]

So there is a rapport between the asceticism of the mystic who seeks to exercise his body (*asceticism* means exercise, the practice of an art) and the painful hard work of the dancer. It is a question of limbering up the body so as to make it responsive to the breathing of the spirit. Dance is an *indwelling* within the body, the witness of an Other. St. Gregory Palamas writes:

"Transformed flesh will also be raised up, enjoy divine communion with the soul, and become itself the home

and dwelling place of God, ceasing to be in any way hostile to God or to express any desire contrary to the Spirit."[7]

The body is the place where the covenant is sealed. Therefore it is also the place where this covenant is the most endangered. All the fears and concerns expressed above can be understood in this sense. The whole question comes back to Paul's challenge to the Corinthians: "Examine if you are in the faith" (2 Cor 13:5). Put another way, see what is the spirit that is transfiguring your being.

The Body's Partner

Let me make more precise what I have just said about covenant. Through dance beauty, the fruition of hard work, and the expression of art manifest themselves in a passing and elusive fashion that is unique each time. Beauty is manifested and then disappears. Nothing remains except the impression that it makes upon the on-lookers. The aesthetic value of the gesture seeks to overcome this elusive quality by heightening the emotion, going farther and investing more deeply. Bodily grace requires that the dancer remain in a state of gracious equilibrium. But, it seems to me, there is a choice to be made here. On the one hand, the body seized by emotion may seek to heighten the intensity of the affective impression that it makes. So dance can become centered on the body which then becomes the exclusive subject of the dance. As in sports, there are records in this competition where a

great reputation becomes compensation for hard work. So there is a product, full of prettiness, but it takes as its reason and its purpose its own success. On the other hand, the body, with all its technique and its grace may decline to become the unique subject of its expressiveness, and then we need to ask what spirit moves it; what is the "body's partner," what kind of pact is symbolized? At this point, let us pull together some earlier aspects of our discussion.

Creation particularizes and identifies, as in birth. The infant's body which comes into the world comes separate, wounded. The human body remains forever incomplete, marked by the fact of its being unable to be everything. It cannot be either God nor the fullness of humanity. It is made *particular* by its limitations—man but not woman, human but not divine. A covenant becomes possible because of this wound and this emptiness. This inability to be everything cannot be remedied like a glass of water satisfies thirst. Instead this absence remains the root of an incessantly repeated and perpetually unsatisfied desire. It is also the location of a new and eternal covenant. The risen body of Christ, a transfigured and glorious body, bears the marks of its wounds, its empty scars where love has been implanted.

The human body cannot be locked away in an illusion of complacency with solitude, nor with feeding on itself reflected in a mirror. It cries out for another and yet it cannot make the other appear. It can only invoke the presence of the other, powerless to force it to be present. This desire is openness, and its power-

lessness before the other is grace. This other that is the body's partner is not the body itself, neither its image nor its double. The body expresses human poverty, our incapacity to provide for ourselves the means of our own fulfillment.

This is why the artistic dream of perfection is linked to the prison of the ideal self. Art never attains its object, for it never ends in possession but allows itself to be drawn into ever greater desire. The reward of true art is an even more demanding artfulness. Rather than imagine some impossible perfection that satisfies our artistic dreams, it is better to speak of quality, of ease. An elusive moment comes close to the ideal; the dream is glimpsed, touched for a moment, and then escapes. Dance, which aspires to rest and which is yet incessantly in motion, is perhaps of all the arts the one which expresses most clearly and with the greatest vulnerability the deep quest that inspires the arts. Dance is the dream of a covenant with the Other. It is a dream which becomes embodied. It is art in all its simplicity. It is a kind of break-through.

Every dance is somehow a holding back of the body, as one might hold back one's words. In discreetly holding back, the wings of one's heart soar up and something is held in reserve for tomorrow. Dance is an art of hope. The other for whom it waits is the unknown whom it desires.

The Silence of the Word
Is dance a kind of language? It expresses not naive truth about the body, but subtle truth that seeks to ex-

press itself in gesture, giving evidence of the spirit that animates it. Though silent, the body still possesses a great range of expression, wider than the range of words. We usually imagine that poetry is expressed by words, while the body is heavy and unpoetic. Popular culture objectivizes body language. This understanding leaves much to be desired. In fact, the body is the "father" of words that flow forth from it, though in doing so they become separate. Words do not return back to the body.

We can distinguish between *sacred dance* which is a search for one's origins (for the father-God, for the earth-mother, for nature) and so is a pre-linguistic quest, and *dance as art* (of which liturgical dance is a part). Art does not go back to primordial beginnings; paradise has been closed down. The separation/distinction of creation has come into being. The only opening now is toward the future, as if our origins could draw us forward and were no longer like a story lost in the past.

To understand all this, it helps to return to the crucified Word. For three years he never stopped speaking, until he entered into a silence of three days. He was handed over into the hands of other men; his body became an object, cut open in a *danse macabre*. But what took place is beyond words. He became this exposed and pierced body, looked upon as an accursed thing (Gal 3:13), abandoned to the repose of death. This silence, this fixity, speak nonetheless— Christ has given his body over to speak of the Other, of the Father. His body has become the message. In

the silence of his sacrifice, he brings together the rhythm and the movement of his existence, the entire dance of his life.

In contrast to the delirium of a trance, Christ opposes the silent concentration of his self-oblation. In contrast to the turmoil of uncontrollable drives, he refuses to come down from the cross to create a condition in which he can be self-sufficient. Rather he remains within this trajectory that moves him toward the Father. His body is free to become a word because it is a body reaching out to the Father.

Examine the exaltation of the prophet Zephaniah:

"The Lord your God is in your midst,
like a warrior, to keep you safe;
he will rejoice over you and be glad;
he will show you his love once more;
he will dance for you with a shout of joy
as in days long ago" (Zeph 3:17).

The dance of God embraces the past filled with sadness and mourning, defeat and exile. He takes within himself, while placing himself in their midst, the mournful body of his people. God's heart beats to the rhythm of human crosses. Having taken unto himself this murdered body, his love renews it and transfigures it. A Paschal dawn of joy and espousals breaks through with divine joy into this emptiness.

What words could speak of the distress of a famished, broken body? Pain no longer finds words: "while I refused to speak, my body wasted away" (Ps

32:3). What poem could express the trembling of the return of life into dried-out bones as a body resting in the earth is renewed? How might one speak of this turn-around, of this resurrection? If suffering leads to muteness, resurrection escapes from the trap of words. It becomes a silence that is the cradle of living words.

Even when the mouth is silent, the body has not yet said its last word. Then begins the dance, be it tragic or jubilant. God dances because the divine heart carries within it transformation and rest, covenant and intimacy. The body of Christ expresses this secret. It reveals this mystery. Beyond words there is a language of the body. This language can be lost in the twists and turns of earthly confusion, or it can allow itself to be drawn together into a unifying silence.

"YOU CHANGED MY ANGUISH INTO JOYFUL DANCING"

Bitter quarrels sometimes come from too much closeness. Look at this: Christianity is a religion of the body—the body of Christ incarnate, the body of the Word crucified, the body of the Son lifted up, the Eucharistic body. The Church is Christ's body. This shows what Christ achieved when he gave birth in himself to a transfigured humanity. If the Church has been and remains suspicious of the body, this is because the body offers the prime temptation toward self-absorption and becomes the principal means for captivating others. This real danger shows however that the occasion for risk is equally an occasion for

transfiguration. Dance is art because it is work, change, a reaching out toward an other. With its work, it joins itself to the movement of faith.

Faith asks dance to translate into art those spaces where our words cannot reach, but where the human spirit moves forward and where Christ himself ventured ahead of us. The language of the body is not simply parallel to the language of words. If words can translate values and their reasons, the body for its part must pay a price to demonstrate their truth. A disincarnated word becomes a dangerous game, doesn't it? To *do* the truth, to *come to* the truth, puts the body in motion. In this sense, the body becomes the truth of words. It is not their formal truth, but their true realization. Further we can say that language moved by bodily experience approaches the limits of verbal expression and remains on the edge of the unspeakable. This underlines the limited character of our language even as it leads us to the gates of mystery.

For its part, dance calls for faith. This is not a facile claim, for there are many dancers who are not believers. Yet as an art, dance gathers up and condenses the essential reality of the human. It moves toward the heights of human expression and toward a glimpsed fulfillment. In this way dance touches upon the sacred, that is to say, upon what is indispensable for living and what gives meaning to life. As such, this sacred reality is open to receiving an infinity of forms. Though malleable, this sacred force, whatever the expressions it may take, maintains a passion for life. In its own order, it is sufficient unto itself.

"The dance will make clear where it is going," responded a dancer to a pianist who had asked how to play a certain piece of music. We can understand the need for a kind of respect based on the understanding of those familiar with the experience of dance. But any reality, whether the dance or the sacred, which sets itself up in autonomy and judges itself, tends to constitute a closed system, an imprisoning self-reference, focused on its own interests, its difficulties, and its failures. Art is not the reason for art, just as movement is not its own end. Otherwise how could we distinguish it from gesticulation? It is rest which gives movement its meaning, the imperceptible instant where the leap maintains its balance before falling back to earth.

In this way dance seizes the body and carries it on toward invocation. Only the Word made flesh can fully engage it. This encounter is not only sacred; it becomes a holy, that is to say, a transfiguring encounter. We meet Christ and dance to the rhythm of a unique but shared love—the love which is exchanged by the Father and the Son in the rhythm and the rest of the Spirit. God dances out of love.

NOTES

1 Jean Chrysostome, *Homélies sur Ozias*, trans. and ed. by Jean DuMortier (Paris: Editions du Cerf, 1981) 157.

2 Ibid., 51.

3 Ibid., 63.

4 *Pascal's Pensées*, trans. by Martin Turnell (New York: Harper & Brothers, 1962). The indication of the paragraph of Pascal's text is given in parenthesis here.

5 *Summa Theologiae*, II II, 168, 3, ad 1.

6 John Climacus, cited by Gregory Palamas, "Sur les Saints Hésychastes," *Philocalie*, 10, 209.

7 Ibid., 212–213.

CHAPTER SIX

A People Baptized
for the Work of Praise

Everyone will remember the Lord's advice to pray in secret: "whenever you pray, go into your room and shut the door and pray to your Father, who is in secret" (Matt 6:6). In contrast to the innumerable animal sacrifices offered by the clergy of the Jerusalem Temple, the letter to the Hebrews explains that Jesus, who did not come from the line of Aaron, is not a priest of a public cult (Heb 7:14). Elsewhere John gives us the response of Jesus to the Samaritan woman who questions him about the place for authentic prayer: "The hour is coming, and is now here, when the true worshippers will worship the Father in spirit and truth" (John 4:23).

Is not a "spiritual act of worship" what Jesus desires, in place of the official liturgies in the Temple arranged by a hereditary priesthood? In place of those celebrations, it would seem better to orientate ourselves like Paul toward "the priestly service of the gospel of God" (Rom 15:16), or toward the offering of

oneself through the sharing of money (2 Cor 8:5). Such things would be "spiritual sacrifices" (1 Pet 2:5) or "a spiritual act of worship" (Rom 12:1) of the new covenant otherwise called "worship in the Spirit of God" (Phil 3:3), for "It is the Spirit that gives life; the flesh is useless" (John 6:63). The gospel would then fulfill the promise of the Old Testament: God does not desire sacrifices (Hos 8:13) and besides, during the time of the Exodus they could not be offered in the desert (Amos 5:25). Now God rejects them (Isa 1:13: "bringing offerings is futile!"). The speech of Stephen in Acts (7:42) refers to this stream of hostile statements against bloody offerings in the Temple. (Not long before, taking too literally Paul's phrase in 1 Cor 1:17, there were some who sought to proclaim the gospel without considering themselves sent to baptize.)

However, "spiritual worship" does not automatically bring about the death of all liturgy. Several reasons could argue in favor of continuing to celebrate liturgical rites. It is useful to make the unity of the ecclesial assembly evident; it is necessary to respect the festive dimension of human existence; it is fitting that a sacrament should seal what has already begun to be lived—thus confirmation celebrates a commitment already begun.

We can immediately see where these arguments come from. They belong to the psychological or the moral order. We need to come together to celebrate events in common and to underline important moments. We should not say that these liturgies do not effect anything—after all they serve to intensify feeling,

to renew our energies, and to celebrate our commitments. They are necessary because of our human, social, or moral qualities. But in reality, they are fundamentally important because of the way human nature is constituted, not on account of faith itself. Liturgies can serve as a bridge between "spiritual worship," which is the most important element, and human nature. Certainly they celebrate Jesus Christ, but a Christ perceived through the life of living persons, since he is there where two or three are gathered in his name (Matt 18:20). Daily life, within which Jesus is already present, is brought to ritual expression in liturgical action.

Liturgy becomes then not a secondary fact, but a second moment that depends upon spontaneous human initiatives. Liturgy is always related to concrete human life. Spiritual worship, either by way of private prayer or by way of service, would be sufficient in itself if it were not for the social dimension of humanity and our affective need for ceremonial support.

The approach just described is, in fact, altogether unsatisfactory. It cannot do justice to the liturgy. Christian liturgy is before all else Christ's worship within his Church which is his Body. This is what we will now try to explain.

THE INCARNATE WORD INTERCEDES FOR US

The summary of the unsatisfactory position which has just been presented requires that we understand well what is meant by "spiritual worship" because this expression is at the heart of the problem.

Everything functions in this explanation as if Jesus, having ascended into heaven, had simply left behind for believers all the consequences of his incarnation in the form of a collective faith supporting the faith of each individual or, we might say, individual faiths grouped together in what becomes the Church. The Holy Spirit serves as the animating principle of a two-fold coming and going between the believer and the believing group and between the assembly of believers and Christ. Thus imagined, the link (whether mediated by a collective reality or not—for this changes nothing in the reasoning involved) has no need to be visibly or bodily expressed. A direct link exists between believing humanity and Christ. There are still certain humanly useful celebrations for which the church provides. Such a position, more frequently held than one might imagine, is inadequate in several respects.

The claim to be linked to God cannot content itself to simply make the claim. A more solid foundation is needed. Put another way, when the author of the epistle to the Hebrews urges "let us give thanks, by which we offer to God an acceptable worship with reverence and awe" (Heb 12:28), it is appropriate to ask on what basis such a link is established. By ourselves, our human works are unable to reach God who remains inaccessible (John 1:18), unless someone who comes from God reveals God to us (John 6:46). It is by Christ and through Christ alone that humanity reaches God; Christ is the mediator between God and men and women (1 Tim 2:5).

We can be certain of this, since the resurrection bears witness that the Father has accepted the sacrifice of his Son. This is the foundation of the Christian life, and so of worship: "For no one can lay any foundation other than the one that has been laid; that foundation is Jesus Christ" (1 Cor 3:11). Christ is and remains first: he is the Head.

The Spirit does not replace an absent Christ. The Spirit makes Christ present for us. The Spirit does not take the place of Christ; on the contrary, according to Christ's own word: "He will glorify me, because he will take what is mine and declare it to you" (John 16:14). The Spirit speaks of Christ in the heart of the believer. Spiritual worship, that is to say worship inspired by the Holy Spirit (Phil 3:3), is Christological worship.

When the epistle to the Colossians writes that "in Christ the whole fullness of Deity dwells bodily" (2:9), Jesus has departed after thirty years on earth. And the letter to the Ephesians describes how Christ, filled with the fullness of God, communicates completely to his body which is the Church (1:23). To impart this fullness is equivalent to pouring out the Spirit in abundance (Acts 2:33).

The Spirit enfleshes: the Spirit presides over creation, over the incarnation, and over the resurrection. At Pentecost the Spirit brings the Church to birth. Far from the Church being the result of the addition of new members, the Spirit-Church precedes their entry. In this way, the Church is called the mother of faith. Baptism joins those who are converted in faith to the

Body of Christ. The Spirit, who is the soul of the Church, brings about the unity of the Church in Christ.

Spiritual worship is the worship of Christ. Since the Spirit speaks of Christ to the believer and configures the believer to Christ, we can understand how the New Testament sometimes uses the same words to speak of Christ or of the Spirit. Christ is the Advocate (1 John 2:1); the Spirit is spoken of this way as well (John 14:16). The Spirit intercedes for us (Rom 8:26) and Jesus also (Rom 8:34). Jesus is the High Priest who intercedes for us throughout eternity (Heb 7:25). This intercession takes the Eucharistic form of his self-oblation on the cross.

This unique and eternal oblation of the Son becomes an act of participation for the entire Body of Christ, his Church, through the action of the Spirit. In the unity of the Spirit one unique sacrifice, one unique act of praise, is presented to the Father by the whole Christ, both the Head and the Body. This is what the final chant of the Eucharistic prayer means: "through him, with him, and in him."

Far from existing for reasons of human cultural interest, far from being merely a consequence of the incarnation related to the fleshly weakness of humanity, the liturgy has as its permanent and fundamental content the work of Christ that is his self-offering on the cross, his return to the Father, and his gift of the Spirit. The Holy Spirit makes this event present to us and brings the new and eternal covenant into our midst.

The liturgy is the worship of the Body of Christ offering itself to the Father in a loving self-gift. It has

been that from the beginning. Liturgy is not a Christian transcription of some ritual instinct common to every religion. It is new and particular in its focus. It is the worship of Christ who founded a new humanity and brought into existence the Church which has no other liturgy than his.

WHAT IS THE POINT OF LITURGY?

The liturgy makes present in the Spirit the founding action of Christ. This is its *raison d'être*. It is this we now try to explain.

Liturgy Is Remembering

For us, remembering is the memory or the recollection of reminiscences of the past. That which we remember is over with. For the Bible, however, remembering is a great deal more than that. Through divine acts in history, God has self-communicated divine being to human persons. Moreover God gives of divine being in an inexhaustible way, so that to make a memorial of the Exodus today is, to be sure, a memorial of a past event, but also an event which has never ceased to speak of the reality of God. The memorial of the Exodus welcomes the present action of God and is open to hope in the on-going faithful gift of God. The memorial of God's action looks forward to God's return.

The Spirit is the memory of the Church: "The Advocate . . . will teach you everything and remind you of all that I have said to you" (John 14:26). When, at the consecration of the Mass, the priest repeats the

phrase of Christ: "Do this in memory of me," he allows the Spirit to make present today that which Christ did in the past. In this way it is Christ who baptizes, confirms, forgives, and consecrates. Each sacrament is a memorial that the Spirit draws from the work of Christ's death and resurrection.

Spiritual worship then is worship that is incarnated in the body of Jesus seated at the right hand of the Father and in the body of the Church. When the First Letter of John describes three witnesses, the Spirit, the water and the blood (5:9), they relate us to Christ crucified from whom flowed forth the water and the blood, the living source of the Spirit. The heart of the memorial is the Cross from which springs forth a living fountain (John 7:39). St. Paul in a similar way ties faith to the blood of Christ (Rom 3:25). Reconciliation with God today is brought about by the blood of Christ (Col 1:20) that the Spirit bestows upon the Church. Thus memorial is the foundation of the Christian life: "The blood of Christ, who through the eternal Spirit offered himself without blemish to God [will] purify our conscience from dead works to worship the living God!" (Heb 9:14). Sacraments are not celebrations of endings, but acts of beginnings. They are both remembering and hope.

Liturgy Is the Source of Conversion

The Christian life does not depend first of all on the moral effort of taking a human decision to follow the example of Christ. Our efforts flow from the gift of Christ. They are the consequence, not the cause of

our following Christ. As the Letter to the Romans explains, we are chosen by grace: "But if it is by grace, it is no longer on the basis of works, otherwise grace would no longer be grace" (11:6).

The first role of the liturgy, particularly within the sacraments, is to give us this grace which makes us conformed to Christ. The transfiguration of the believer by the Spirit comes about through the believer's union with the incarnate Word who reveals the Father and leads toward the Father. This is Christ who has taken upon himself all that is human. His Spirit leads toward this unique point, the Cross, where lifted up from the earth, Jesus draws all to himself (John 12:32). The liturgy bestows this attracting force which is the power of conversion. The splendor of Christ sacrificed, the beauty of his offering, and so his glory—all this transforms believers to turn them into children of God (2 Cor 3:18).

It is always Christ who converts us. He does this by means of his incarnation, our only anchor on the path toward the Father. The gospel is about Jesus who is seen and heard and touched (1 John 1:1-3). Conversion then is taking into ourselves the mystery of Christ offering himself to the Father.

Liturgy Builds the Body of Christ

Christ, says the Letter to the Ephesians, fills up his Church with his own fullness. He purifies it "by cleansing her with the washing of water by the word" (Eph 5:26). The First Letter of Peter speaks in a similar way of baptism: which is "not a removal of dirt from

the body, but an appeal to God from a good con-science, through the resurrection of Jesus Christ" (3:21). A good conscience is the fruit of the resurrection, that is, a result of the fact that Jesus acts and is made present among us.

The old adage of Pseudo-Jerome, "the Church makes the Eucharist and the Eucharist makes the Church" is helpful here. Christ nourishes his body (Col 2:19). The verb "to make" does not have the same sense in the two cases. The Church "makes" the Eucharist, that is to say, celebrates it and renders it present through the liturgy. But the Eucharist "makes" the Church in the sense that it constructs and builds it up. By the Eucharist, Christ makes the Church a living reality. The liturgy is a vital action; in it Christ gives himself through the Holy Spirit so that the Church will be irrigated with his grace. The Church is born of this everlasting gift which always goes before it and which upholds it in its being. This is the meaning of the old adage "the Spirit is the soul of the Church." The Church has been preceded by a gift that has called it into being, a gift that makes it new and holy within the world—the gift of the resurrection.

The nourishment given by Christ maintains the unity of the Church. This unity, the "cohesion" of the Body (Col 2:19), does not result from social consensus which leads Christians to come together simply to strengthen their relations; the communion of the Church derives from the same unique source, the gift of Christ, which upholds his Church in love. The unity of the Church is not a consequence of our human de-

cisions nor of our manipulation. This unity precedes our action. It is always the Spirit which "brings about the good will of all the people" (Acts 2:47).

So liturgy is at once a given and an art. It is a given, because its origin is Christ. It is an art in the sense that what it is about is signifying this gift and making participants ready to receive it and understand it. Celebration opens hearts and illumines intelligence. The aim of this art, which is a way of doing—a craft— is to create a people as people of God. This people is not "of God" because they imagine themselves such; it is because God chooses and calls them. To celebrate therefore means to reestablish the resonance of this call and to make people hear this Word. Liturgy is obedience, a listening to the Other. Gestures, words, and silences evoke this Other who is the origin of everything—Christ. He speaks and gives himself within the celebration of his living word and of his sacraments.

Liturgy Brings Us into the Heart of God

Baptism is conferred with a Trinitarian formula, "in the name and of the Father and of the Son and of the Holy Spirit" (Matt 28:19). The Christian gesture, the Sign of the Cross, brings together the remembrance of the death of Christ with the Trinitarian profession of faith. At Mass before the consecration, the priest begs the Father to send the Spirit so as to make real for us the presence of the body and blood of the Son. The Eucharistic prayer closes with a Trinitarian doxology.

In the liturgy, Christ gives his own life, his Spirit, to believers. He makes us "participants of the divine

nature" (2 Pet 1:4). The Spirit whom he has sent to us unites us in a common existence as children of God (Rom 8:16), and the Son leads us to the Father and places us in the hands of the Father. It is the Father who has given us the Son. The liturgy introduces us within the Trinitarian economy, permitting us to partake of the intimate life of God, to dwell within God's love. Liturgy is the source of the spiritual life. Liturgy even now bestows the fulfillment of our human vocation, that for which we were created. Thus liturgy becomes praise and thanksgiving for the gift received; it becomes worshipful silence and contemplation.

At the same time, liturgy roots the Christian life in the solemn celebration of the life of Christ who reveals the Father. It establishes spirituality within the objectivity of the incarnation, placing the realism of the life of Jesus at the heart of all mystical yearning. If the spiritual life allows the believer to plunge into the liturgy, the liturgy for its part spares the spiritual life from uncontrolled enthusiasm and affective deviations. To internalize liturgical actions is to recognize the incarnation as the path toward the Trinity.

Finally liturgy creates hunger and thirst. The more liturgy experiences blessed intimacy with God, the more it comes to desire this intimacy. Liturgy remains fundamentally an act of hope which cries out "Come, Lord Jesus" (Rev 22:20). Within liturgy the earthly already tastes the Kingdom of God. It receives the first fruits (2 Cor 1:22). In the Eucharist a new world arises, the risen world of the Son who is the new creation (2 Cor 5:17). But this reality has not yet been achieved,

as the Letter to the Hebrews explains (2:8). Liturgy yearns for the full manifestation "that God may be all in all" (1 Cor 15:28). Christ has begun to bring all things together in himself (Eph 1:10); the liturgy allows us to take part in this work of renewal and communion. Liturgy integrates the communion lived by the Church with its mission to carry to the whole world the offering of full communion.

THE BEAUTY OF GOD

Solid argumentation can bring about assent, although the freedom of a person might resist by reacting either positively or negatively, perhaps even superficially. A willing commitment, however promising, does not exhaust the power of the will itself, since the will is always able to take back or re-give itself with further consideration. The logical power of a faultless argument can oblige human intelligence to respond positively, but it cannot force a deep interior conviction. There are some truths that we will agree to without having the depth of our being touched. Full commitment, coming from the will, shows signs of a willingness which gives itself freely, knowing in its heart of hearts, that it consents precisely because it wishes to do so.

If persons are going to give themselves fully, what they need is not rigorous argument, nor a decision which will leave the core of the will intact. Something else completely is needed which does not pertain to reason or to the will. There must be a consent of our very being which gives itself freely. Reason is not rea-

son for itself alone, nor is the will. We cannot prove the logical necessity of love, no more than we can demonstrate the requirements for a commitment. To will to love is more limited than to love. Freedom is not taken from someone; it must be given. What brings freedom to give itself can only be in harmony with freedom, and thus gratuitous. At the heart of the arts we find such gratuity, at once a free gift and the most needed good. The arts are at one and the same time creative and faithful; an action which is unfettered, but disciplined in its execution.

A free person lives freely by this gratuity which attracts and liberates. This grace calls forth beauty.

Beauty—Fascinating or Seductive

Beauty is manifest in two forms, it is at once fascinating and seductive. Its fascination attracts us, but it imprisons us (like Eve with her eyes fixed on the forbidden fruit, forgetting everything else). In the same way snakes fascinate frogs—to devour them. Fascination attracts freedom to engulf it in objects, turning it in upon itself. This is the fascinating beauty of the prostitute of the wisdom books (cf. Sir 25:21). Some celebrations celebrate only the pleasure of being gathered with friends. Such moments flatter or charm us; they have as their goal to please people (cf. Gal 1:10), and as such they enslave them. Far from being liturgies celebrating the Other, they are celebrations of ourselves, festivals of narcissism.

On the contrary, seduction draws us out of ourselves. The One who attracts, leads us on unknown

pathways. God seduces Israel to lead Israel into the desert (Hos 2:16); Jeremiah finds in the enchantment of God the power to place himself at God's service despite all the persecutions he relates in his prophecy (20:7). Such beauty manifests itself, but cannot be possessed. It invites, calls forth, attracts like Christ on the cross (John 12:32). We are invited to touch, approach, and discover a beauty greater and more elusive than we can know, just like Thomas at the feet of the Risen One (John 20:28). Such a beauty signifies encounter and covenant. This beauty influences without forcing itself, it constrains no one, it begs for a free gift both generous and poor. For what it desires is precisely contact with the freedom of the Other.

The liturgy is at the service of this free and attractive beauty. Liturgy resolves an ambiguity about beauty, where believers risk becoming bogged down or lost in enthusiasm. Liturgy is at one and the same time both rigorous and supple. There is rigor because of liturgy's source: it comes from Christ. There is rigor in its gestures and its rites which have been given to it. This rigor directs liturgy toward the Other, reaching out toward the one goal of encounter. Liturgy is not given over to perpetual inventiveness, rather it is guided by a tradition which mediates Christ to us.

But liturgy knows suppleness as well, for it serves life: "for freedom Christ has set us free" (Gal 5:1). Rigor is the bone structure of suppleness. The Spirit can be recognized in this ease, the ease of children who dwell in the house of the Father: "Son, you are

always with me, and all that is mine is yours" (Luke 15:31).

The Truth about Being Human

Because it is about freedom, liturgy is about life and death. The water of baptism, even more than washing, signifies that water which imparts the death and risen life of Christ. Baptism becomes the cradle of life. In the Eucharist, we take bread and wine which give life; other forms of food allow death to approach us. Oil reminds us that without it, the human body would dry up like a corpse in the sun. Put another way, the liturgy roots humanity in the realities that make the human person to be human. We deal with much more than a superficial attachment to ritual details.

So liturgy is about the truth of being human, what it is that makes humanity really live and what helps it to enter into the true human vocation to divine life. Liturgy is eminently serious, but also filled with gracious joy.

These qualities help us to understand inevitable questions about liturgical beauty. This beauty enhances the attractiveness of the truth. Beauty is fitting to the truth of Christ in the sense that liturgy is the worship of a mystery that remains always beyond our capacities of expression. It never suffices then to satisfy aesthetic tastes; we must be led into silence before the divine presence, to adoration. Beauty equally serves the truth of the assembled people of God. This people is what it is with its distinctive tastes, age, history, sufferings and hopes. It is such people, with

their concrete limits, who will be led by prayer into the presence of Christ. People come to be baptized, to be married, and to be buried. People come for this and we can do little about their previous condition of faith. The art of liturgy, however, consists in opening them up a little more to the Christ who comes to meet them. The art of liturgy is welcoming.

Aesthetics remain secondary by comparison to this first quality of hospitality. Aesthetics are at the surface of encounter. Great organ music can either help or kill a celebration! Everything depends on the way it is used. The arts are indispensable, on condition that the people understand them as an opportunity to help them grow in openness. It is less a question of "putting sacred art at the level of the people," according to the phrase of Georges Braque, than permitting people to speak their genuine truth before Christ. Artists can aid in this powerfully. Artists cannot replace the people who pray or substitute for those who are searching for God. Artists can articulate the desire which dwells in these people, indeed they can help people to transcend their desires. For, in evoking the truth of the believer before God, liturgy becomes a kind of incarnation.

We enter into the liturgy through baptism which makes believers "united with Christ in death like his, . . . and certainly united with him in a resurrection like his" (Rom 6:5). Baptized, the Christian has become a participant in the liturgy of Christ. Baptism makes the believer a liturgical person. Just as the Spirit of Christ holds together the Body of Christ, so the baptized celebrates truly when he or she is in the

middle of brothers and sisters in the faith. The great prayer is the prayer of the Church. Prayer "in secret" prepares for or prolongs the celebration of the people of God. But it is the people's prayer that is the source of all prayer, since the Spirit creates this body, "interceding for us in sighs too deep for words" (Rom 8:26). The presbyter who presides symbolizes Christ as pastor who gathers his people together and Christ as Head who leads them to the Father. He maintains their unity in their dynamic orientation toward the Father. For this unity is journey, movement, and life. It is a communion and, by way of the progression of this communion, a departure and a mission. The liturgy takes the world in its hands to offer it to God. It consecrates the world. People who are baptized, consecrated by the Spirit, are a people whose whole life becomes a work of praise.

Index

renounce personal singularity,
26, 46–47; who are unbeliev-
ers, 31, 40; work of, x
Asceticism: related to dance 142;
of time, 83
Assembly: coming to existence
in liturgy, 17–18; gives mean-
ing to space, 113
Augustine, St., 9, 128

Baptism, 169, 170; as the cradle
of life, 168
Baroque excess, 12
Beauty: ancient definition of, 19;
arises out of rhythms of word
and gesture, 78–79; in Bible,
20; divine, 37, 39; and elusive
quality in dance, 143; and
faith, ix–x; as fascination,
166–167; invested in the as-
sembly, 15–17; as a passage to
action, 9; *philokalia*, 76, 79; re-
lated to time, 81; renewed
through arts in liturgy, 16; as
seduction, 166–167; signifies
encounter and covenant, 167;
strong and weak moments of,
x; transfigured, 20; and the
truth, 168–169
Believer, the: and the artist, x
Bernard, St., 25
Bethel, 100
Bible: on beauty, 20; connects
dance with God, 123–124
Body: chaos of, 92–93; of Christ,
transfigured, 8–9; of Christ, as
place where charity becomes
visible, 107–108; of Christ, as
symbolic site of beauty, 8–9;
of Christ, as word, 146–148;
covenant in a, 142–143, 144;
created incomplete and lim-
ited, 144–145; and dance,

124–125, 142, 148–150; language
and expression, 145–148; and
its "partner" in dance,
143–145. *See also* Human being
Bouhier, Jean: dance as immod-
est: 131–132

Celebration: helping a people to
pray, 48–49; of liturgy, xiii, 2,
66, 154–155,
Chaos: of a body, 92–93; in
space, 90, 91–92
Christ: as only actor in liturgy,
47; as axis to a dynamic
process, 108; body as word,
146–148; celebrated in liturgy,
155–159; as the covenant,
100–101; as creator and re-
deemer, 15–16; as the founda-
tion of worship, 157; fullness
of, in liturgy, 15–16; and full-
ness of time, 64–66; and in-
carnation, 37; maintains the
unity of the Church, 162–163;
as mediator between God and
humanity, 156–157; as the
"narrow gate," 106; made pres-
ent by the Spirit, 107, 156,
157–158, 159–160; revealed in
the liturgy, 7; and sacredness
of liturgy, 29; as Temple of the
Church, 104, 106. *See also* Body:
of Christ
Christianity: as religion of the
body, 148
Chrysostom, St. John: criticism
of theatrics in liturgy, 126–127
Church: architecture of, 119;
early, and art, 49; built up by
the Eucharist, 110; as Christ's
body, 148; communion of,
162–163; as constructed eccle-
sial space, 112, 113–115; entering

as a journey experience, 17, 118; epiphany-like, 118; as an historical place, 116; as a microcosm, 120; and the necessity of the arts, xi; orientation of, 94–95, 117; as sacred space, 44–45, 46, 94–95, 104; and the Spirit, 157–158; as a symbol, 104–105, 109, 111–112; as a temple of Christ, 104, 106; many titles of, 49; is Universal, 105; as useful outside the liturgy, 115–116, 118. *See also* Sacred space

Commitment: requires consent of our being, 165–166

Community: as space, 115–117

Conversion: in liturgy, 19–20, 41, 161

Conscience, good: the fruit of the resurrection, 162

2 Corinthians 3:18: beauty as transfiguration, 20

Council of Orange, 38

Covenant: in a body, 142–143, 144, 145

Creation: as divine plan, 36; handed over to humanity, 111; of humans, 137, 144; and transfigured Body of Christ, 8–9

Creativity: as transcendence, 141

Cross, 46, 106, 110

Curé of Ars, 131, 134

Dabar, 71, 73–74

Dance: as an art, 134–136, 145, 146, 149–150; in the Bible, 123–124; condemnation by Jansenist reaction, 129–131; dangers of, 129–131, 133, 135, 136; exclusion of, in history, 125–134; as expression of the body, 124–125, 142, 148–150;

calls for faith, 149; of God, 147–148, 150; morality of, 136; as a language, 145–148; and moral decline in late Roman antiquity, 125–126; and Pascal's condemnation, 129–131; playful quality of, 134–136; and problem with modesty, 132–133; as a production of the natural, 135–136; provides only the illusion of life, 130; rest gives meaning, 142, 150; sacred, 123, 149, 150; Saul and Salomé, 132–133; as transfiguring encounter, 142–143; seen as a vulgarity in the Church, 128–129

Dancers: difficulties with Church, 124–125

Desire: of humans, 17–18, 144–145

Dialogue: structure of sacraments, 71

Dictionnaire de théologie catholique: against country dances, 133–134

Disharmony: of arts and liturgy, 23–27, 29–31, 43, 45

Divine initiative, 36; as sustained by liturgical cycle, 69

Duration: of time, 66, 67

Easter, 19

Ecclesial space, 89–121; designed for a community, 115–117; as epiphany-like, 120–121; escapes two dangers, 120; four elements of, 116–117; does not limit hope, 105; not limited to the church building, 116–117; as a present moment, 108; reveals the covenant, 120; transforms the ordinary, 114–115; and the word, 109

of Christ, 155–159. *See also* Worship

Logic: of art, 139

Malraux, André, 16

Material: and transition to symbolic, 98–101

Media: effect on liturgy, 84

Medieval Councils: exclusion of dance from Church, 127–129. *See also* Dance: exclusion of

Memory: as foundation of Christian life, 159–160; liturgical, 51–53; loss of, between art and liturgy, 53; and possibility for hope, 82–83

Modesty: as not a part of dance, 132–133

Moses: and God's divine beauty, 37, 39

Music, liturgical: distance from secular, 41–42

Mystery: in the liturgy, 39, 44, 46

New Testament: and use of term "liturgy," 3–4

Order: and symbols, 101–102

Ortolan, T.: and dance as art, 134–135

Palamas, St. Gregory, 142–143

Pascal, 136; and condemnation of dance, 129–131

Pastor, 60–62; *See* Priest

Paul, St.: and brevity of time, 63–64; and veil of Moses, 39

Pensées: and condemnation of dance, 129–130

Pentecost: as summit of liturgical year, 78

People: of God, 17–18, 49, 163,

169; symbolism of, in liturgy, 16–17

Philokalia, 76, 79, 82

Prayer: authenticity, 153; as a part of celebration, 48–49; as a source, 170; as time within liturgy, 72–73

Preface of the Dedication of a Church, 101, 121

Priest: double role in liturgy, 10, 12; and liturgical rhythm, 78, 79, 80, 81; as shepherd of time, 60, 62, 70, 75, 76, 82

Promise: of God to Jacob, 99

Rebirth: in time, 63–64

Reconciliation: of arts and liturgy, 40–43. *See also* Art: and liturgy

Remembering: as a part of liturgy, 159–160

Renunciation: in liturgy, 48

Resurrection: brings renewal of everything, 65

Revelation: provides meaning in world, 36–40

Rhythm: of word and gesture in liturgy, 77–79

Ritual: and meaning in liturgy, xiii; materialism, and result in liturgy, 11

Rouet, Bishop Albert: and parabolic activity of human action, viii–ix; and parallel between faith and beauty, ix–x; and principles important for pastoral life, viii–ix; theology of, viii–ix

Sacrifices: spiritual, 154

Sacramental: cycle, 76; theology, and conditions for liturgy, 46

Sacraments: dialogue in, 71; in

Timothy, Second Letter to,
106–107
Topor, Roland, 7
Transfiguration: as art, 140–141;
of believer by the spirit, 161;
through dance, 142–143; as
part of liturgical action, 41, 42,
50; and true liturgical poverty,
48
Transformation: of the arts,
40–41; difficulties with, 8; of
humanity, 39; in liturgy, 5, 7;
of time, 67
Transition: from material to
symbolic sense, 98–101
Trinity, 163–164; and liturgical
time, 68–69

Unity: of the Church, 162–163;
the invisible as foundation
for, 14; of liturgical objects
and artistic action, 47–48

Universe: as divine space, 120

Victorinus, Marius, 8
Violence: of dance, 133
Volunteer ministers, 19–20

Will: power of, 165
Wisdom: as being present to
what we do, 79–80; and the
divine plan, 36–37; necessary
in Christian life, 76
Word, the: crucified, 146–147;
depth of, 73; dwells in the
Church, 109; gives meaning to
liturgical acts, 70–74; rhythm
of, 77–79
Worship: gives meaning to time,
84–85; purpose of, vii; role of
the arts, vii–viii; spiritual,
153–155, 157–158, 160. *See also*
Liturgy

Zephaniah 3:17: and dance of
God, 147

Liturgy and the Arts was written by Albert Rouet
and translated by Paul Philibert, O.P.
The text was set at The Liturgical Press
in Aries and Perpetua Titling,
typefaces designed by Eric Gill, T.O.S.D.
The book was designed by Frank Kacmarcik.

Versa Press, Incorporated, printed the book
on Glatfelter Natural paper and bound it
in Gainsborough Cover Plus by Simpson Paper.